HANDBUILT
ceramics

JO TAYLOR

HANDBUILT
ceramics

THE CROWOOD PRESS

First published in 2021 by
The Crowood Press Ltd
Ramsbury, Marlborough
Wiltshire SN8 2HR

enquiries@crowood.com
www.crowood.com

© Jo Taylor 2021

All rights reserved. No part of this publication may be reproduced or transmitted in any form or by any means, electronic or mechanical, including photocopy, recording, or any information storage and retrieval system, without permission in writing from the publishers.

British Library Cataloguing-in-Publication Data
A catalogue record for this book is available from the British Library.

ISBN 978 1 78500 959 4

Cover design: Sergey Tsvetkov
All sequence photos taken by Jo Taylor; for makers' credits, please see Contributors page at the end of the book.

DEDICATION
For Barry and Oscar

ACKNOWLEDGEMENTS
I would like to thank the amazing contributors to this book and I am extremely grateful to Paul Briggs, Lynda Draper, Mark Draper, Madoda Fani, Wanying Liang, Claire Partington, Eusebio Sanchez, Dirk Staschke and Patricia Volk. Without their generosity, this book would not have been possible. All have kindly given their time, knowledge and stunning images for all to enjoy.

I am indebted to Tessa Eastman for the initial recommendation and to Louisa Taylor for her pragmatic advice, proofreading and support with this project. Thank you for your time and patience, proofreaders Julie Fitzpatrick, Jasmine Hearn, Yasmeen Khatib, Jane King, Jo Sterrick, Oscar Taylor and Patricia Volk.

A special thank you to photographer Layton Thompson for going above and beyond; to Kelly Berman at Southern Guild for superb communication; and for the continuous support of Crowood Press, which was very much appreciated for my first outing.

And finally, you have both been in my thoughts throughout this process: Michael Pennie and Kevin de Choisy.

Graphic design and typeset by Peggy & Co. Design
Printed and bound in India by Parksons Graphics

CONTENTS

1	Introduction	7
2	Materials and Equipment	11
3	Inspiration and Planning	21
4	Pinching and Coiling	37
5	Slabbing and Press Moulding	57
6	Sculpting and Additional Techniques	77
7	Surface Treatment Pre-Firing	99
8	Firing, Glazing and Further Techniques	115
	Contributor Profiles and Photographers' Credits	135
	Glossary	139
	Resources	141
	Index	144

CHAPTER 1

INTRODUCTION

People have been hand building with clay for around 20,000 years; ceramics offer many clues to human development through archaeological finds. The use of clay has always been wide-ranging to include objects for rituals, storage and serving food, expanding through the centuries alongside technological developments in the processing of raw materials and more efficient firing methods. From the largest national museum to the smallest local museum, it is fascinating to see how people in your district or from further afield made and used fired clay objects. Local resources influenced the material constitution of objects; custom and function influenced form and decoration. As humans we are still fascinated with shaping soft clay using our hands and a basic range of tools; its tactile, responsive quality could almost be described as addictive. Although we can now purchase the materials we need in store or online, it is interesting to consider that many of the methods used today were applied using a high level of skill across the continents thousands of years ago.

In our modern age with its sophisticated technology, it may seem surprising that the analogue activity of working with clay is more popular than ever. In the UK, accommodating this demand in a changing educational landscape has led to an increase in the number of courses being run by collectives and individuals in ceramic studios, outside of general education facilities. No matter what is 'on trend' people have always and will continue to attend classes for reasons such as enjoying a creative, grounding activity and receiving a warm welcome in a diverse and sociable group. Goals can be achieved, such as creating specific objects, trying something new, and learning

Mark Draper, press-moulded elevation with mould.

skills. Some make objects they can use, give as a gift or sell; for some, what starts as a hobby can lead to further education or a change of career.

Learning by observation and through feeling with your hands what clay will (and will not) do is as important as instruction. Much of a learner's progress will be 'kinaesthetic', which is the activity of learning by doing, as tuition will only take you so far. Watching people working with clay, both on television and online, is ever more popular; observing making in all its variations can quickly aid understanding. As a consequence of suiting different learning styles, ceramics retains universal popularity across a range of settings as it is an appropriate activity for anyone. It is widely accessible: most issues can be accommodated and it is a proven beneficial activity for well-being. It is also an excellent means of building resilience and problem-solving skills, alongside the development of creative and making skills.

◀ Jo Taylor, detail from *Cincture* wall series, 2019, porcelain, thrown, hand-built and assembled.

Wanying Liang, hand-modelled work in progress.

Eusebio Sanchez, scoring coiled work in progress.

The route to ceramics is not always linear; the percentage of mature students on courses is testament to this, as many start their journey later in life. My passion for ceramics was sparked when attending evening classes, a weekly gathering of a diverse crowd of people excited by the possibilities that making allowed. A patient and knowledgeable tutor guided us, inspiring an eagerness to learn, and for some this enthusiasm led to a career in ceramics. My first tentative step was to set up a small workspace at home to make pots, alongside my 'proper' job. This interest grew, although it was frustrating trying to work things out pre-internet; many books seemed excessively technical or prescriptive. Needing to know more about this complex subject I committed to studying for a degree; feeling lucky to have the opportunity to learn, experiment and appreciate the company of experienced tutors and enthusiastic students. As soon as I graduated, I changed career and began teaching, combining this with making and selling functional tableware.

I returned to study for a Master's degree and began exploring hand-building techniques, while resting a shoulder injury which meant I could not throw. This led to an experimental approach to making, through combining several construction methods. Since graduation in 2012, I have been working from my small studio in South West England, alongside teaching ceramics in a range of settings including schools, colleges, universities, a prison, care homes, arts centres and museums. Working with all types of students I have been able to understand the joy ceramics can bring to almost anyone, regardless of disability, dementia, learning or behavioural issues.

This book is written with all kinds of makers in mind: the intention is to write straightforward, practical explanations and be a friendly, reassuring voice in the studio. It is not exhaustive; there is enormous variety in how people approach ceramics and there is no right or wrong, as long as it works for the individual. The aim is to foster experimentation based on sound understanding of techniques; we all have times when things might not go to plan, but there will be discoveries along the way and 'happy accidents'. Through years of making and observing people in the classroom it is clear that the more you work with clay the more you discover for yourself.

The content of this book covers the following: setting up a workspace, the practicalities of making, and kilns, including

Claire Partington, detail of figure from installation, *Taking Tea*, Seattle Art Museum, 2018.

important health and safety information. A chapter about inspiration and planning discusses different approaches to the conception and development of a project. The basic building techniques are demonstrated: pinching, coiling, slabbing, press moulding and modelling, as well as mixing techniques and experimenting. Decorative techniques, such as sprigging, adding texture, colouring clay, using slip, paint and glaze, are explained alongside firing information. Included are practical tips and an appreciation of different approaches. I write from years of experience as a learner and teacher, so my knowledge is a mixture of information gained from peers, tutors and technicians, and from reading and my own discoveries. When checking facts, I found it is not unusual to discover a diversity of approaches; at those points I have acknowledged the range in which makers work.

Besides outlining techniques and sharing my own practice, I have invited a diverse range of contemporary makers to contribute to this book. These inspirational ceramicists have generously shared many aspects of their approach to hand building and their contributions will enable readers to appreciate how building skills and experience alongside creative drive can deliver accomplished results.

The group was selected carefully; although at different stages of their careers and with contrasting practices, they all challenge themselves and the material. Their integrity and craft skills are evident; each combines ongoing curiosity with sophisticated problem-solving skills. Many discuss working intuitively; this way of working evolves over time as part of the ongoing dialogue between maker and matter. Origins of inspiration are wide-ranging and revealing; it is fascinating to consider the variety of source material and technical processes, many of which have been adapted to suit the works concerned. This means the book is essentially by makers for makers – every person involved allows the reader to gain an understanding of their personal conversation with this most responsive of materials.

Jo Taylor, 2021

CHAPTER 2

MATERIALS AND EQUIPMENT

This chapter summarizes the materials and processes that support the activity of making and offers practical guidance for working safely wherever your space is, from a kitchen table to a purpose-built studio.

TYPES OF CLAY

Clay is an amazing material and the possibilities for manipulating it are almost endless, so understanding its origins and the varieties available helps to inform the work made. Clay is formed naturally from the erosion of weathered rocks over hundreds of years. The rock particles are washed away and gradually ground down by moving water, which is why clay is often found close to rivers and lakes, or where there has been water in the past. Anyone can dig clay from the ground and process it manually by drying it out, adding water, then soaking and sieving it. The inclusion of local minerals will influence the colour and performance. The majority of makers buy clay that has been commercially extracted and processed. This has the advantage of having consistent quality and performance and being ready to use as soon as you open the bag.

The range of clays available from a supplier can be overwhelming, so a little planning will help you make the right decision. Think about the size, function and finish of what you want to make – do you want to make a large work? Will it go outdoors? Is it for regular food use? If so, will it go in the microwave or dishwasher? Is it decorative? Will it live safely on a shelf or mantelpiece? Is the colour of the clay important or will you paint or glaze the surface? Do you already have a glaze in mind?

Choose a clay body to suit the firing temperature you require; having a rough idea about the finished object will help. Clay is often labelled as 'earthenware', 'stoneware' or will state a cone number, which refers to the recommended temperature range at which to fire the clay. Choose 'stoneware' and a high firing if you want to put your work in the dishwasher, microwave or outdoors in frosty conditions; 'earthenware' suits decorative works or less frequently used functional pieces that will be washed by hand. Many suppliers sell small sample bags so you can try out an unfamiliar type of clay before committing to a regular 12.5kg (27.5lb) bag or more. They will normally give guidance about the properties of each clay on their website, with images to help with colour choice.

The most popular clay to start with is a general, multi-purpose type, often labelled 'school' or 'college' clay, which suits beginners and most types of domestic scale projects, whether functional or sculptural. This clay will have a broad firing range, meaning it can be fired to earthenware or stoneware temperatures and is fairly forgiving, making it a good place to start. For texture, clay with added grog (ground fired clay) will give a progressively rough surface, dependent upon

Image of Wanying Liang's studio.

An example of the range in texture and colour of raw clay.

the grade of coarseness of the grog. Normally called 'crank', 'sanded' or a 'grogged' version of a regular clay, it can range from feeling slightly sandy to having little hard chunks mixed in like aggregate. Adding grog decreases the overall shrinkage, as the grog has already been fired. Grog may have the effect of making clay less 'plastic', but it offers better support when making larger works as it is less prone to sag, or even collapse, in the building process.

Molochite is a white version of grog made from calcined china clay and is used in the same way to reduce shrinkage and add texture and 'tooth' to the clay body to help support the building of larger works. You can buy grog and molochite separately and mix them into clay in your own proportions if preferred.

Terracotta, or red earthenware, is coloured clay often associated with bricks and flowerpots. Colour comes from the presence of iron oxide in the clay, which occurs naturally in many parts of the world. Terracotta can have a high plasticity which means it will bend and stretch well, but it will also have relatively high shrinkage. If your work is not dried under carefully controlled conditions it may be prone to cracks and breaks even if your thickness is even. Terracotta will need to be kept separate from white clays as it will stain them easily with brown marks. Washing your tools and workspace thoroughly between using different coloured clays will help to avoid contamination.

Terracotta has a beautifully rich tone when fired and works particularly well with slip decoration. Normally fired to earthenware temperature (up to 1100°C or 2012°F) to retain its classic colour, the finished work will be slightly porous and therefore not as tough as work fired to higher stoneware temperatures (up to 1300°C or 2372°F). This affects its suitability for use in the dishwasher, microwave and outdoors in frosty conditions. If fired to higher temperatures the colour darkens to a rich brown and it may warp, crack or become bubbly in texture, which is not suitable for functional ware but can be interesting for sculptural work.

White earthenware is commonly used in educational settings – as the name suggests it is similar to terracotta, or red earthenware, except for the colour. It suits the lower temperature range well and the joy of firing to a lower point means less energy consumption and a shorter firing cycle: firing is discussed in detail in Chapter 8.

Black clay is prepared commercially and there are several versions available, with tones varying from brown-black to a more purple-black. A variety of grogged versions are also

Dirk Staschke, *Soliloquy no. 4,* 2017, height 71cm (28in) x 53cm (21in) x 23cm (9in). The rich colour of the clay used in the frame is shown in a more immediate state, combined with lighter-coloured clay in the rear view of this intricate sculptural work.

Porcelain coloured with blue stains in preparation for Nerikomi technique.

12 Chapter 2 – Materials and Equipment

Wanying Liang, detail from *Woman as Vessel* series, 2020, glazed porcelain.

available, as is black porcelain. The colour is achieved by mixing oxides or stains into regular clay – you can also do this yourself. How to colour clay is explained in detail in Chapter 6. Be aware that some black clays are not food safe due to the oxides used, so always check with the supplier or manufacturer if you are thinking of using black clay to make tableware. A limited number of coloured clays are also available to buy commercially, mainly in greys, blues and greens.

Porcelain is a white, highly plastic clay with fine particles, high shrinkage, and a fascinating history. There are many versions available commercially with slightly differing qualities designed to be better for throwing, or for translucency, for modelling or even self-glazing (Parian). What they all have in common is the whiteness which makes a superb base for many glazes or looks equally beautiful with no glaze at all. Many makers colour porcelain with stains or oxides as the white base gives excellent clarity of colour.

Porcelain has a reputation for being a little difficult, but it is more about understanding the practicalities of how it behaves; you have to get to know it. It will stretch and bend more than other types of clay, it can be worked until it is very thin so as to be translucent, but it will also shrink more than any other clay (up to 15 per cent). It will absorb water like a sponge and become saturated easily, making it floppy. This can be controlled if you limit how much water you use, take extra care with any joins, and manage your drying carefully. It is also important to use a clean workspace to avoid contaminating the porcelain's purity as any debris from other clays, glazes or general mess are guaranteed to show up in the firing, which is always in the stoneware range (up to 1300°C or 2372°F).

Paperclay is exactly that, clay with paper pulp mixed in. You can buy it in regular and porcelain versions or make your own by mixing slip with soaked, shredded paper. There are variations in recipes and processes, so it is worth a little research to find the best method to suit your needs if making your own. The home-made version can be prone to growing mould, so only make up what you need and avoid storing it for long periods of time. The advantage of paperclay is that its fibre content provides support, making it popular for figurative sculpture. The paper element burns out during firing, so the resulting work is much lighter than 100 per cent clay pieces. It does feel a little fibrous to work with, but like porcelain it can be worked until it is very thin and quite unlike any other clay it can be used raw on to dry or even bisque work for repairs or to continue building.

Getting to know the clay you are using is the best recommendation for understanding how it works, as you can better gauge what it will and will not do. Ask yourself how it feels to work with, how much will it stretch or bend? What happens when you add water; is it easily saturated? How much does it shrink? How carefully should I dry it? Does it crack easily? It's useful to talk to your supplier or other makers for recommendations. It's helpful to remember that ultimately it is all clay particles, just with different additives that change the colour or texture, so there is much common ground.

STATES OF CLAY

Several terms apply to clay in its various states: 'greenware' is clay that has not been fired. Until it goes into the kiln it can be broken up, reclaimed and made back into workable, soft clay.

'Leather hard' (sometimes 'cheese hard') applies to clay that has dried halfway between soft clay and bone dry – it is still workable but feels stiffer and is how many slab-built works are made. 'Bone dry' means the clay has completely dried out, which results in it looking much paler and chalkier than when moisture was present. It no longer feels cold to the touch, and it is at the most fragile point in the whole cycle, requiring the greatest care when being handled.

'Bisque', 'bisc' or 'biscuit' ware applies to clay that has been fired once to a comparatively low temperature of around 1000°C, or 1832°F, and is still porous. It has turned from greenware into fired pottery and cannot be reclaimed; it is ready for glazing and a second firing. 'Earthenware' applies to the lower of the traditional glaze firings, up to 1100°C or 2012°F. 'Stoneware' applies to the higher of the traditional glaze firings, up to 1300°C or 2372°F. Firing will be explored further in Chapter 7.

Patricia Volk's studio: kiln, just opened, revealing bisque work.

CLAY PREPARATION

Clay will keep for years in a soft, workable state if it is stored in a tightly closed plastic bag, so when not in use always close the top with a few twists and secure with the wire to keep it airtight. Some makers store clay in an old fridge or freezer, which will keep it airtight and protect it from frost if it is stored in an outbuilding. Makers with indoor studios will normally just stack bags of clay out of the way under a table. Check the bags for little holes which sometimes appear at the suppliers or in transit; you can simply place the whole thing into another bag and seal or put waterproof sticky tape over the hole. Be aware that any exposure, however small, will cause some degree of drying so keeping the clay properly sealed will save work later on.

Wedging is the act of kneading clay to prepare it for use by ensuring a uniform consistency and eliminating any air pockets. It requires a bit of muscle and for some, it also prepares the mind for the making that follows. It is not necessary to wedge all clay – many makers use it straight from the bag if it is even in consistency, often as a result of the industrial mixing processes (pugging) before being bagged up. The exception to this is porcelain, which often feels quite hard when you open the bag, but softens quickly after wedging.

Good wedging skills are very useful and can help, not just with preparing clay but also with softening it, mixing in coloured stains and for reclaiming – recycling – your scraps back into a usable state. It can be tricky to get the hang of initially, but like many aspects of ceramics, honing your technique involves practice and getting the feel for it. Avoid tiring muscles by only preparing what you need for the next couple of hours and work on a table at a comfortable height. Wedging can be performed on a plaster bat or wooden board which will dry it very slightly, or on marble or slate, but avoid plastic surfaces as the clay will stick.

To wedge, take a large lump of clay of a manageable size compared to the size of your hands and pat it into a round shape. Standing feet apart will help provide stability as you motion forwards and backwards. Place the clay on your chosen surface and push the heels of your hands firmly into the clay, pushing it down and slightly away from you. Gradually curve upwards at the end of the motion, letting your body follow the movement.

Next, pull the clay back towards you and rock back slightly with your body. Repeat this pushing, pulling and rocking motion, occasionally turning the clay 90 degrees to ensure an even process. To check if you have removed air bubbles, wire the clay in half and look at the cut surface for anomalies. If it is smooth and even you have done a good job: if not, slam the clay back together and try again; it can often take a few attempts. There are many variations of this method and to view the technique in action there is plenty of online film footage of makers wedging.

Depending upon what you are making, you may want the clay to be softer or firmer; you can harden clay by drying it in the air for a little while before wedging, or soften it with water or slip by wedging it in. If it's rock hard, skip to the next paragraph on reclaiming. If you can push a pencil into it, poke long holes throughout with a wooden stick (a pencil or long-handled paintbrush works well), then add water to the holes, seal tightly in a plastic bag and leave for a day or two to let it absorb before wedging. Alternatively, you can wire the clay into slices (approximately 1cm or half an inch thick), paint each slice generously with water or slip and stack them like a sliced loaf. Cut the loaf in half with a wire, slam the clay together and wedge, repeating if necessary. This method is a little labour-intensive, but you can control exactly how soft you want the clay to be.

To dry clay, form it into thick arches on a board or plaster bat, then using your fingers poke it all over to make small indentations to increase the surface area. Depending on the room temperature and air flow, leave the clay for a short while and re-wedge when it feels a little drier. Sometimes just a quick wedge on an absorbent plaster or wooden surface will dry it enough for your requirements. It can be interesting to mix two types of clay together to add the texture of one to the colour of another – just wedge them together and wire through to check they are mixed thoroughly.

RECLAIMING CLAY

Makers are thrifty types and appreciate the opportunity to recycle: reclaiming is the process of reworking scraps to produce fresh, workable clay for future masterpieces. It can be labour-intensive, so it is much easier to reclaim small amounts regularly, rather than save up dustbins full of slops. Save up scraps including any offcuts, disasters, spare handles or unused bits – any clay that has not been fired. Set aside a plastic pot or small bucket to collect them in and leave until the pieces are bone dry. To begin the reclaiming process, add enough water to cover the clay pieces. Notice that the clay breaks down very gradually upon contact with water; clay particles are heavier than water and will sink to the bottom. Keep adding more scraps as you work; it may take a few weeks (or even months) to amass a reasonable amount depending upon your process.

When you have enough soaked clay to reclaim, make sure your plaster bat is clean and clear, and discard the excess water from the top of your pot by gently tipping it away. Add the sticky slops evenly to the plaster bat: poking holes into the slops will increase the surface area and aid the drying process. Drying time depends upon how thickly the slops are piled and the temperature in your space, so it could be ready in an hour or it might take a day. Check to see how it is progressing by seeing if you can lift the clay slightly on the underside where it touches the plaster. This part will dry first as the porous plaster absorbs water from the clay slops faster than air will dry the top half. When you can lift it a little, flip the slops over in sections to allow the plaster to dry the wetter half. Once you can lift this side a little it is ready to wedge back into workable clay, and seal in a plastic bag ready for use.

Porcelain is the exception to this method as it loses its elasticity when bone dry and can become crumbly and unworkable if reclaimed in this way. The best way to avoid this is to add all scraps to a bucket of water before they dry out. The scraps will absorb water while soaking and become soft, so you can slop it onto the plaster bat and follow the same steps of allowing it to dry a little before wedging and bagging. Reclaimed paperclay can lose its strength but is still useful as a filler. If you use different types of clay there is nothing to stop you putting all your scraps in one bucket. You will end up with a hybrid with the colours and qualities of whatever went into the bucket, and it will be perfectly usable.

Plaster bats can be made using potters' plaster purchased from your supplier – once made they should last for years. Your plaster bat need not be enormous; the size depends upon your needs in terms of reclaiming. To be able to absorb water during the reclaim process it needs to be quite thick – most are between 5 and 10cm, or 2 and 4in. Production methods vary, but you will need something to act as a mould. A wooden frame on glass is a popular method, or you may find a flat-bottomed plastic tub that is the right size and shape. Whatever you use, if there is a possibility the plaster will stick, any area

RECLAIMING AND WEDGING

Step 1: collect scraps of clay in a bucket and allow to dry.

Step 2: add water and leave the clay to gradually break down.

Step 3: tip excess water away and place slops on to a plaster bat.

Step 4: once the slops have dried a little, lift the clay and flip over to dry the other side.

Step 5: pat the clay into a ball and push down with the heels of your hand.

Step 6: keep pushing the clay away from you in a rolling motion.

Step 7: pull the clay back to where you started and repeat the pushing and rolling motion.

Step 8: the clay will start to look like this; the technique is known as 'rams head' wedging.

Step 9: cut the clay in half with a wire to check for air bubbles.

16 Chapter 2 – Materials and Equipment

that might come into contact with it will need greasing with soft soap, Vaseline, liquid house soap or releasing agent. If there are any small gaps in the mould where the liquid plaster could escape, plug them with a little soft clay.

Work on a flat surface to ensure the plaster bat will be an even thickness – check with a spirit level if you are unsure. The plaster to water ratio should be stated by your supplier as this can vary slightly. It is important to wear a respirator mask and protective gloves for mixing up; always measure the water first and add plaster to the water to avoid making additional dust. Sprinkle the plaster onto the water evenly and stir gently, getting right to the bottom. Try not to make bubbles – you can gently tap the bucket to encourage them to rise to the surface and skim them off. Once the plaster starts to thicken pour it into your mould. Once set it can be released from the mould and will need to dry thoroughly before use. For further research there is a range of film footage online demonstrating different approaches to making a bat.

WORKSPACE PRACTICALITIES AND ESSENTIAL HEALTH AND SAFETY

People work with clay in all types of spaces – it may be a temporary set-up for a couple of hours, a purpose-built studio in the garden or a shared studio in a communal building. If you are setting up at the kitchen table you will need little more than a board to work on, a couple of basic tools and a large bowl of water for cleaning up. If you are setting up your own studio there are essential considerations to help you work comfortably and safely in the longer term. If you are working in a shared studio or classroom most of this may have already been set up for you. Whatever the set-up, there are common material hazards to be aware of and ways to make your working position a comfortable one, as it is easy to become absorbed for hours at a time with your latest project.

The common hazard with all clay is dust. Airborne clay particles when inhaled are too fine to be expelled, so can collect in the lungs over several years, leading to silicosis. This must be taken seriously but there are simple ways to ensure safe working: once water is added, dust is no longer a hazard. Always wet clean your workspace and tools using damp sponges and a mop and bucket. Get into good habits, such as keeping a sponge handy to clear up any mess as you go and ensuring tools and boards are cleaned after each session. Never sweep with a

Patricia Volk's studio with work in progress.

brush or use a dustpan and never create dust by working bone dry clay. Make sure the floor where you are working can easily be wet cleaned – many studios use smoothly painted concrete floors, tiles or lino.

Sometimes dust forms as you slowly use up a bag of clay; it can be cleaned easily by wiping the area where residual clay has dried, normally just inside the bag. Clay will also dry out on your hands so wash or wipe them with a sponge regularly. Aprons and rolling cloths should be washed after each session to avoid becoming dusty, and it is worth thinking about the shoes you wear in the studio – one solution is to use old sports shoes which can go in the washing machine. For any processes that involve ceramic powders or dust, such as mixing or spraying glaze, always use a respirator mask, which can be obtained from your supplier or online and will last for a few years.

Some hazards exist in glaze ingredients; suppliers will produce detailed COSSH sheets for all products so you can understand what is in the product and take any steps necessary. Certain ingredients are no longer available in certain countries depending on their health and safety laws. For example, lead was used historically in shiny earthenware glazes, but acidic food such as vinegar and citrus caused the lead to leach into the food. Labelling varies, but most commercially produced glazes will state whether they are 'dinnerware safe' and therefore suitable for use with food and drink. Labelling and information is normally very clear and you can always talk to your supplier for clarification if you are unsure.

Being comfortable while working is important to keep aches and pains at bay; it is easy to become absorbed in your work in an awkward posture or use repetitive actions and get

Chapter 2 – Materials and Equipment

Mark Draper at work in his studio.

Claire Partington at work in her studio.

painful strains. Similar to the recommendations for working at a computer, be aware of the height of your table; if you like to work seated, think about your chair height and if you work standing up think about your table height. If you are setting up a studio, ensure that your main workbench is the right height from the start as the optimum height will vary from one person to the next. If you are working at a predetermined fixed height you can add boards to increase table height or put props underneath the table legs if you are tall. You can add a cushion to your chair if you are shorter; even swapping chairs or stools for a different height can make a noticeable difference. Taking regular breaks and mixing up your physical activities can also help avoid discomfort.

Looking after your back is important, especially when manual lifting – a 12.5kg bag of clay is heavy, so always lift equally with both hands and bend your legs to protect your back. Do not twist or lean sideways and keep the weight close to your body. If anything feels too heavy do not lift it; ask someone to help you rather than risk injury.

Good lighting is important, especially on dark winter days or evenings. Avoid being in the way of a light source as you will end up working in shadow; an additional table lamp can direct light to where it is needed. If you are building a studio, a skylight is an excellent addition for daylight working.

Looking after your hands is also important as frequent contact with clay can dry your skin and cause irritation. Many makers are happy to use hand cream to address this; others work using disposable gloves to protect their hands. Despite their disposable nature, you can re-use them until they break and a box can last for years. Gloves are advisable when mixing glaze and plaster.

The disposal of water containing clay is an important consideration. Do not dispose of this water in your domestic sink as clay particles are heavier than water and have the potential to sit in bends and block pipes. If you are working at the kitchen table, use a large plastic bowl or small bucket half-filled with water and a big sponge to wash your hands and tools. This makes it easier to take outside and pour it on a neglected part of the garden where it can soak into the earth.

If you are setting up a studio with a sink you will need a sink trap. This is a deep plastic tub that sits underneath the sink (or sometimes to the side). The waste pipe from the plughole feeds into the trap, creating a space for the heavy particles to settle at the bottom, leaving clear water at the top. A waste pipe fitted to the top of the trap, on the opposite side to the feed, filters the clear water into the regular drain system. These are cheap and easy to DIY with a plastic crate, or they can be bought commercially. Over time, sludgy sediment will build up at the bottom and requires emptying occasionally. There are different thoughts on disposal, and it depends on whether or not there are any hazardous chemicals from glaze present. Using rubber gloves, scoop the sludge into a plastic tub. Allow it to stand in an undisturbed area until the water has evaporated. If it is not hazardous, it can be disposed of with regular waste. However, if you have glaze mixed into your waste be aware of the ingredients; for example, copper, cobalt, manganese, barium, amongst other elements, are classed as hazardous materials and will need to be disposed of at your local council facility – your supplier's COSSH sheet will help you determine what is in your glaze.

If you are setting up a studio space at home or in an outbuilding, consider insulation and heating so you can be comfortable when working in winter – do not rely on kiln heat as you should not work in a space when the kiln is firing. Kilns emit harmful fumes that vary depending upon what is being

fired. Organic matter in any clay, but particularly paperclay or clay with flax, will burn early in the firing cycle. Depending on glazes and clay composition, other fumes, such as sulphur dioxide, will burn later in the cycle. In a professional set-up, such as a college or university, the kilns will be in a separate room with an industrial extraction system for this reason.

For a smaller scale set-up, consider where your kiln is sited and how you will ventilate the space – it also needs to be set a short distance away from any walls to avoid becoming a fire hazard when it is very hot and to allow access for maintenance. A separate room or building is ideal, but if this is not possible, stay well away when firing is in progress. Ventilation can be achieved using an extractor fan, opening windows and skylights or fitting air bricks – any combination of these will create a draught to help draw the fumes away. Professional extraction may be a consideration and kiln suppliers can offer advice on this. If the kiln is firing near your living space, in an annexe or conservatory for example, ensure a carbon monoxide alarm is fitted as a precautionary measure as it can be emitted during firing, depending upon what is in the kiln.

ESSENTIAL TOOLS

In terms of equipment and tools you need very little to get going; traditional makers in hot countries use hardly any water and only their hands and a pebble or bamboo rib to make incredible coiled pots. Some items can be appropriated from another part of the house, such as a rolling pin, large car cleaning sponge, scissors, bucket, old credit/bank/loyalty card, and a rolling cloth made from an old tea towel or pillowcase. Suppliers will have no end of tools to tempt you, but key basics include a potter's wire, metal rib (also called kidney), serrated rib (or kidney), craft knife, a potters' pin/needle, a diddler (sponge on a stick), scoring tool and some soft goat-hair brushes (these are not regular paintbrushes, but specifically made for ceramics). Collect plastic tubs with lids from yogurts and takeaways, and if you can acquire a larger tub or two with a lid (like those used in food outlets for mayonnaise) you will definitely use them. Sheets of plastic are invaluable, particularly the thin, clear sort used to cover clothes from dry cleaners and online purchases.

Working on a board is ideal to enable you to move your masterpiece around with less chance of damage. Always use a wooden board as clay can stick to plastic. You can buy good quality round boards from your supplier or cut them yourself if shape is unimportant; scrap stores often sell them cheaply. A turntable or banding wheel will be expensive but is a worthy investment as it will be used frequently for working on a piece from all angles and will last you a lifetime. There are cheaper turntables made for decorating cakes, but these are not robust enough for larger, weighty ceramic works.

Tools and equipment will be discussed in relation to specific making methods throughout the book – everyone has favourites and many makers adapt or make their own tools to suit their style of work. There will be glimpses into the studios of the makers featured in the book as they discuss works in progress and include information about types and states of clay in relation to their techniques.

Basic tools, left to right: wooden right-angled rib, potters' wire, scoring tool, craft knife, diddler, sculpting tool, metal ribs (or kidneys), flexible rib (credit card) and wooden bowl rib.

Madoda Fani at work in the studio.

Chapter 2 – Materials and Equipment

CHAPTER 3

INSPIRATION AND PLANNING

Finding inspiration, planning and starting new work is an enjoyable process; new possibilities are exciting and the opportunity to use invention and imagination is a driving factor for many artists. This chapter discusses a range of approaches to finding inspiration, how artists reach decisions about what to make and attitudes towards planning. The contributors provide a fascinating insight into the origins of their work and explain how inspiration influences their process and outcomes. Approaches vary enormously as the creative process is personal to each individual and most settle on a routine that works well for them practically and makes them happy.

Planning can be a linear process starting with observation and gathering visual information, then working in a sketchbook where ideas are developed on the page before being taken into 3D. In contrast, some makers go straight to clay in a less formal, spontaneous or intuitive way, allowing for changes to happen during the making process. Many people, as well as artists, describe a state that happens during physical activity that is sometimes called being in the 'flow state', 'zone' or being 'hyperfocussed', where you are immersed in a process or concentrate on something so hard that you lose track of everything else going on around you. This often happens during creative activity, and it can be a point where changes happen in your making or drawing that you are not fully in control of. Many artists engineer opportunities for this type of absorption within their process; sometimes it happens anyway. Raw clay is very responsive and the pleasure that comes with being 'in the moment' is proven to aid well-being.

Mark Draper's studio wall: plans and drawings.

Inspiration can be sought internally or externally; it can come from an emotion, experience or idea, by viewing images, interacting with objects, animals or people, or from visiting a specific place, museum or exhibition. People develop distinct interests from childhood and are often naturally attracted to particular types of source material as a start point. This can be general or quite specific, but it makes sense to begin where you already have knowledge and enthusiasm. Purpose or place can be a primary concern if work needs to function or is for a specific location. Other start points could include social comment or political statement; there may be a theme for an exhibition, or work may be designed for a particular person, as with commissions.

Museums are a frequent reference point for many artists, as a place to research ideas, processes and historical contexts, and offer plentiful stimulation for new directions. Landscape and nature provide direct inspiration across many art forms; if a place or object appears true to life it is often described as

◀ Lynda Draper, *Spring*, 2018, height 70cm (27.5in).

Patricia Volk's sketchbook record of acrylic colours.

Author's sketchbook: idea for a wall-hung series.

Author's *Cincture* series, porcelain, 2019.

'representational'. In contrast 'abstract' work is less literal and relies upon interpretation by the artist. Gathering items of interest from books, online or when out and about can help build a comprehensive resource to draw upon at a later date. This could take the form of photographs, notes, drawings or gathering found objects, such as leaves, driftwood or discarded items. If you are drawing from personal experience and are seeking to express a thought, emotion or memory, a sketchbook is a useful tool for making marks to communicate your experience. Sketchbooks are a useful tool for gathering visual information; they need not be about making beautiful pictures, for example it may be a place to document inspiration like a scrapbook or to process ideas using the roughest of diagrams.

Whatever your approach, keeping a notebook or sketchbook can also help to record processes and materials used, to help repeat successes and avoid disasters in the future. Working through what a piece might look like, considering measurements and shrinkage, and recording thoughts about making and drying time to help meet a deadline all help address potential issues. It is possible to solve many visual and technical problems before you touch clay by taking a little time to get a clear idea of where you are going. It could be a way of choosing what profile you want for a coil pot, considering colour options, working out how to get the largest work possible into the kiln or to help you explain how the finished work will look to a gallery or client.

Planning is generally a flexible process; there is even flexibility at the making stage, but one aspect of ceramics that cannot be altered is shrinkage – this affects your final outcome and may be more or less important, depending upon your intentions for sale or display. It is crucial to consider this for commissions or making work that needs to be of a specific size. All clays vary; the total shrinkage of a grogged piece will be around 8 per cent when fired to stoneware temperatures (up to 1300°C or 2372°F), which is considered quite a small amount from raw to finished. Porcelain shrinks at around 15 per cent from raw to fired (always to stoneware) which can be a surprise when you open the kiln and see how small it has become. To accurately measure shrinkage of a particular clay in a specific firing, roll out a small slab and score out a 10cm (or 5in) line; measure the line after firing to precisely work out the shrinkage. Some ceramicists make notes about the techniques, colours and firings of each piece – it may be interesting to measure and take images of work before and after firing.

Approaches to making vary with each individual; it is always interesting to hear about the thought process behind a piece of work. Talking through ideas with other artists, makers or tutors is often a useful activity to help clarify a project; they may spot potential issues, recommend further research or make useful connections. Ceramicists normally have good networks either locally or online (few work in total isolation) and it can be an important and enjoyable part of your artistic activity to share information and ideas.

CONTRIBUTORS

The contributing makers illustrate a range of approaches to planning; sometimes meticulous preparation is essential or some create items in a way that is instinctive and spontaneous. Working intuitively comes with experience and knowledge; over time, clay teaches you what it will and will not do. Our hands have a memory of their own and fine motor skills develop from time spent pinching, squeezing and forming. It is interesting to consider where ideas come from, how they result in a drawing or object, and how works and thinking develop over time. What inspires us is often deep-rooted and personal; even if it isn't always apparent in the final work, it is part of the journey.

Eusebio Sanchez, *Exposed*, 2019, height 52cm (20.5in).

Museums are a rich source of inspiration and sharpen observation skills; many artists remember objects seen during childhood. Patricia Volk: 'I am very visually aware; as a child my Mum would send me to Ulster Museum to get rid of me – I loved looking at the sculpture and saw it as something to aspire to.' Eusebio Sanchez: 'The prehistoric Jomon pots in the V&A resonate with what I'm doing; the coil is the decoration, and the symbolism is very enigmatic: you don't really know what you are looking at and I enjoy the mystery.' Claire Partington:

> My inspiration comes from a mix of museums, shop display and illustrations in books; going to the museum gets you looking and being observant of small details. Growing up in Northamptonshire, I would go to the local museum, which had a collection of shoes; it was a shoemaking town. The collection included elephant shoes, Elton John's shoes, tiny Chinese shoes for bound feet, as well as seventeenth- and eighteenth-century shoes. These exquisite objects were fascinating to me and the craftsmanship was incredible.

She discusses the importance of medieval sculpture when considering three-dimensional works:

> Viewing intricate brass plaques and marble death monuments in churches can give a better idea of the clothes people wore. You can see in the round, which you do not get from two-dimensional paintings. People who make

Claire Partington, bisque figure, work in progress for *Taking Tea* installation for Seattle Art Museum, 2018.

reproduction costume make pilgrimages to these churches to see the statues, to understand how these clothes were constructed.

Childhood, culture and heritage are significant to the inspiration of many makers. Wanying Liang:

I was born in a conservative region of China – Shaanxi Province, which still retains many traditional customs and rituals. For local events, people make special food and decorations to celebrate or to mourn. I rarely paid attention to them and never related them to art until I left home. I found these rituals and decorative objects genial and warm to me when I was alone, far from my hometown and my family. My dear grandmother left us in 2015; for the last part of her funeral our relatives burnt paper-made objects called Zhizha in front of her grave, carrying our wishes for a peaceful and prosperous life in another world. The fire combined our best wishes and sorrow for the loss of our loved one. I followed the tradition, attended every ritual of my grandma's funeral, which lasted for several days. After the funeral, I felt I had been comforted with a real goodbye to my dear grandma.

Another ceremony people attach great importance to, in my hometown, is the wedding. At a conventional wedding, an essential decoration is called Huamo (flowery flour buns). They are made by local craftswomen and are given to the new couple as a gift. The delicate and gorgeous Huamo conveys a cheerful and ecstatic atmosphere, and the vitality of life. These decorations and rituals influenced my work extensively. People put their yearning for the good life and afterlife into these exquisite decorations. For me, these decorations combined people's beautiful wishes and the cold reality that most people could never realize these wishes. At the same time, the decorations are a sign of my nostalgia. My works are nourished by all of these.

Wanying Liang, drawing.

Wanying Liang, *I Do Not Know I Am A Guest When I Dream*, 2018 installation at Alfred University, US, showing finished work, *Gravity in Pray*, height 178cm (70in).

Chapter 3 – Inspiration and Planning 25

Madoda Fani also takes inspiration from culture and heritage, as well as the local landscape and nature:

> I've been inspired by many things. When I started working professionally (in 1999) I was inspired by nature, plants and animals. As I began developing my work, I started to look more closely at what I liked and what is interesting to me; I became inspired by landscape, buildings, insects and specifically by an animal called the armadillo. So, in my work I always try and combine all those elements into one piece, while making sure that my greatest inspiration, which is my heritage, shows in my work.

Architecture is a regular source of inspiration for several makers, whether the significance is cultural, historical or structural. Wanying Liang:

> There are architectural elements in my works. Symmetrical form and multiple levels stem from the shape of the pagoda, which is religious architecture. The pagoda conveys tolerance and the beauty of balance, which is pursued in my works as well. I also like to add costume elements in my works. Elements such as the shoulder pad-shape, lace, and hemline, could be found in my sculptures. And since I live in a rural area now, the beautiful nature I can see every day, including animals and plants, are my inspirations as well.

The work of Paul Briggs has two distinct strands, with nature influencing his pinched work, contrasting with his slabbed pieces, which are influenced by architecture and address pressing social questions:

> The inspiration for my pinching work was initially the process itself, and intuitively responding to the medium. Eventually, the colour, surface, and textual transitions in nature became important – as Ruskin said: 'Nature makes no aesthetic mistakes'. For my slab work, ancient architectural forms have long been my primary inspiration and my ideas are usually dealing with spiritual social justice issues. Ultimately, I am concerned with the interplay between failing social systems and the individual.

Madoda Fani, *Intilizyo*, 2020, height 76cm (30in), detail.

Paul Briggs, *Windflower* series, vessels with variegated green glaze, 2020, heights 14cm (5.5in) and 19cm (7.5in).

Paul Briggs, installation *Cell Personae*, 2020, each work approx. height 20cm (8in). Having taught art to inmates through prison ministry, the artist was inspired to create this body of work addressing the devastating effects of mass incarceration on Black lives in America. Using space as a metaphor, each of these twenty-five sculptures references the dimensions of a jail cell.

Chapter 3 – Inspiration and Planning

The author uses the physicality of architecture as inspiration:

> Much of my work is inspired by architecture, particularly decorative features such as plaster ceilings. I enjoy looking at shapes, details and surface from a sculptural perspective, and considering how light and shadow create dramatic contrast. I take pictures on my phone at places of interest, so have a library of images stockpiled for future reference.' Observing architecture in person gives an unrivalled experience in understanding scale, form and structure for Mark Draper: 'The selection of the subject is intuitive; sometimes I'm asked to make a representation of a building, but I have to be inspired in the first place. Apart from the Hartenstein Hotel (in Holland) and Hawkfield Lodge (which doesn't exist any more), I always visit the buildings to get a feel for them; first-hand observation informs the decision-making throughout the duration of the project.

Observation plays a crucial role for Patricia Volk, when both seeking inspiration and assessing her own work:

> Everything influences me all the time; every day I walk around and see something exciting. For me it is all about line and composition; I look at sculpture from all angles as the sides and back of a form, and the space around it – all are equally important. I look for sculpture that moves me emotionally and has presence; I'm interested in how pieces work with each other and the negative space between them.

Moving ideas from 2D to 3D can be straightforward or a complex process. Claire Partington: 'I've always been able to think in 3D – as a child playing with plasticine or Blu-Tack, or even a Kit Kat wrapper; I would make little shoes and goblets.' Mark Draper:

> Once the drawings are completed, I photocopy them and paste them on to cardboard. I then begin to build up the 3D image; I enjoy this

Patricia Volk, *Bloom*, 2018, height 100cm (39in).

Mark Draper, cardboard maquette for a ceramic model based on Cliveden House, 2020.

Chapter 3 – Inspiration and Planning 27

Dirk Staschke, *Soliloquy* 2, 2016, height 74cm (29in), front and rear views.

stage as I begin to see the form take shape. I can see if the model is going to be too big or small and can adjust the size by scaling my drawings up or down on the photocopier. This is why I never know the exact scale of the pieces. My studio shelves are full of the maquettes because I haven't the heart to throw them out although I need the room in the studio. On a model, roofs are very important because you look down on the piece. It is essential therefore to include the details such as ridges, valleys, vents, chimneys, lead rolled joints. I use Google Earth to find out what the roofs of buildings look like. Once I'm happy with the look of the card maquette, I will look to start modelling the elevations in clay.

It can be challenging to take inspiration from the two-dimensional and turn it into a three-dimensional work; this challenge is at the core of Dirk Staschke's practice:

> My work is influenced by Dutch vanitas paintings and becomes an attempt to find the metaphysical in the mundane. I endeavour to explore the space in between sculpture and painting that neither medium can occupy alone. Look behind a painting and the illusion of space is lost. My work seeks to give that space a tangible form. Like the façade of a movie set, the knowable gives way to a backdrop of structures that exist in support and in reaction to its creation. Representation becomes a departure point and a foil for examining skill and craft.

Starting with a clear historical reference point, as the viewer moves around the work it reveals aspects of its structure and the qualities of the raw material, intended as antithesis to the highly crafted front.

Exploring relationships between the classical and the contemporary is a rich line of enquiry, as explained by Claire Partington:

> I'm an observer and a people watcher; character in stories and characters in the street, how people choose to present themselves and what they associate themselves with by what they wear. Some things you can't choose, but you can choose what clothes you wear, for example a football shirt, which has associated cultural and social aspirations. Shoes like fake Gucci flips-flops have associations and are depicted in my work; there is a relationship with Roman sandals seen on classical sculptures.

Spontaneity, the flow state and abstraction are appropriate to the themes that inspire Lynda Draper:

> My work explores the intersection between dreams and reality. I'm a huge advocate of daydreaming. Many ceramic sculptures evolve from a state of reverie shaped by fragmented images from my environment, memory, culture and ghosts from the past. I am interested in the relationship between the mind and material world and the related phenomenon of the metaphysical. Creating art is a way of attempting to bridge the gap between these worlds. I am also intrigued by the way material culture is utilized to assist in the mediation of loss and change. I have a fascination with pareidolia, the tendency to perceive a specific, often meaningful image in a random or ambiguous visual pattern, and the phenomena of universal mythologies linked to the spirit image. My work aims to invite imagination and the contemplation of some kind of other realm.

Drawing can be part of the process: 'I sometimes work from preliminary sketches and draw potential future works if I don't have access to clay.'

A way in which many makers use drawing as a tool is for problem solving. Dirk Staschke: 'My approach to planning is usually done without sketches as I feel my way through a sculpture. Sometimes I will do small thumbnail sketches without detail if I'm having a hard time arranging a composition. If I am feeling really stuck, I can take a photo of a work in progress with my phone and in the flat image it is easier to see what needs to be changed.'

Lynda Draper, *Annette*, 2013, height 52cm (20.5in).

Using drawing to bring accurate detail into his work is crucial to Mark Draper:

> Sometimes I sketch the building and also make rougher sketches to work out how to build the piece. I take many photographs, taken square on as I use them to help me draw the elevations. I take close-up images of any ornamental details. Sometimes up to 100 images are required; I get them printed and pin them up in my studio so that I can work from them. I then make architectural drawings of the buildings – rarely, I can obtain copies of original architectural drawings, which saves a lot of time.
>
> My drawings aren't fine examples of draughtsmanship, but they are fit for purpose and enable me to go to the next stage, which is to make the card maquette. When making the drawings, I am mindful that they are for a clay model, so what will assist me with the production of a plaster press mould is important as opposed to a drawing that would be handed over to a builder.

A sketchbook is crucial for working through an idea from the initial inspiration to planning a 3D work for Wanying Liang:

I use both a sketchbook and a notebook; a sketchbook is more helpful to me. I usually record my instant imagination in my sketchbook and refine it later until it looks right to me. Sketching helps me to ensure the details of my plan. It is a process of transforming my vague idea into an actual design. It is exciting to transform a two-dimensional image into a three-dimensional object.

Another reason why sketching is so important is that my works are usually built of several parts. The dimensions of each part need to be accurate, especially at the assembled section. I need to calculate the size in my sketchbook and then start working on it with clay. Besides, sketching and calculating size is vital to an artist who works in his/her own studio with only one or two kilns. I learned it from an awkward experience when I first started working in my own studio. I didn't calculate the size very carefully and made the work a little bit bigger than would fit into my kiln. I could never fire it in my studio and had to remake another one. This accident cost me almost one week and delayed my process. Only a tiny deviation makes the work not able to be fired. It is very disappointing to find it out when you spend days and nights to make the work and are very excited about firing it. It is a material waste too.

Wanying Liang initial sketch, sketch with measurements and final form, Untitled, 2020, height 140cm (55in).

30 Chapter 3 – Inspiration and Planning

Moving from sketchbook to maquette to final piece hones the decision-making process for Madoda Fani:

> I always start with sketching in my sketchbook. After that I will make small items at a size between 10 and 15cm (4 and 8in). The small items help me to see the possibility of the final items. When I am happy with the small items then I will begin with the final piece.' Eusebio Sanchez also finds it useful working from small to large: 'Smaller works have advantages of needing less storage space, a smaller kiln and they can be used to try different things to move the work forward – I make small sculpture as sketches for the next body of work. It also gives me a form to try out colour and glazes to achieve new finishes.

This also forms part of the making process for Paul Briggs: 'I use a sketchbook, but as a support to modelling ideas as small works.'

For some, a sketchbook helps with decision-making; it can also be about presenting ideas to others. The author:

> Sketching for me is a way of taking the source material and getting to know it well, the angles and details, and looking at potential outcomes, opening up a wide range of possibilities. Then you narrow down, choosing what to take forward first and working out sizes and colours. It can be helpful to sketch an impression of finished work ahead of making for a gallery or client. For specific projects, keeping a sketchbook can make it easy to explain visually how thinking and work has progressed over a period of time. I sometimes use a sketchbook to plan for exhibition – how works might look when grouped together, how I might show them.

Jo Taylor, *Vari Capitelli i–iii*, 2019, tallest height 44cm (17in).

Jo Taylor's sketchbook: ideas for *Vari Capitelli* series.

Chapter 3 – Inspiration and Planning

Claire Partington: 'Not much goes into a sketchbook; the only time I drew out an idea was for the Seattle Art Museum as I needed to give a presentation. I used Photoshop to collage and drew the figures so they could understand the narrative and how it worked in relation to the objects in the room.'

Installation view of *Claire Partington: Taking Tea* at Seattle Art Museum, 2019 © Seattle Art Museum.

The importance of line is a concern in both drawing and sculpture. Patricia Volk:

> Sometimes there will be a drawing as a start point, more of a doodle, which I don't normally keep. I enjoy life drawing, which I see as keeping fit for your work, in terms of observation and making marks. What is most important is the line, which is a profile or gestural motion with freshness – I'm trying to capture a good line. Visually it is important for a form to feel light at the bottom so there is no heaviness, almost like it is floating slightly – this is so important to me.

Eusebio Sanchez:

> I don't often sketch, but I will use drawing to help work out how to develop a piece if I'm stuck, as I find it is useful for problem solving. Paul Klee talked about taking a line for a walk, an active line moving freely without a goal – the coil is my line. In a world that is becoming digitalized, I have created a relationship with clay where my hands act like an analogue 3D printer and as a result my sculpture echoes the aesthetic of this technology.

32　Chapter 3 – Inspiration and Planning

Patricia Volk, *Breeze*, 2018, height 85cm (33.5in).

Eusebio Sanchez, *Toes by the Shore*, 2019, height 158cm (62in).

Intuition is a word frequently used to describe process; applied to both the act of making and judgements about form during the build phase. Patricia Volk:

> When I am making, the form evolves completely by eye – I check measurements occasionally with a tape measure so it will fit into the kiln, but I get it right with a mental image of the size more often than not. At various points I leave myself options to change the arrangement of component parts or the colour (I use acrylic paint for the surface) so I can revise any previous decisions and remain flexible to allow the work to develop as it evolves.

Eusebio Sanchez:

> When I am making a piece of work, I know where I want to start and have a notional idea of how I may want it to look like. Frequently the work takes me on a material and narrative journey and as I progress, I make decisions to shape the final form differently to the one I had in mind. I let the form be, and I let serendipity happen in the search for a new structural complexity. My process is a journey – I can't control it, it just ends up being what it is – the work is expressive, not political or a statement, and I try to get away from the figurative.

Many works can be described as drawings in clay. Lynda Draper:

> My most successful works evolve organically, often from a state of subconscious reverie – musings leading to my hands to make marks, form clay structures or reassemble fired components. I also like to work in a way where there can be options after the firing process. Often, I build works as separate components and attach them after firing. Sometimes I'll put pieces away for a couple of months and revisit them with fresh eyes. The skeletal

constructions evolve organically and intuitively, they are I suppose 3D clay drawings. There is a freedom in working in clay this way, the forms grow and unfold. Initially, there is no intention that they will become anthropomorphic, the collaging of coloured ceramic pieces onto the skeletal constructions seems to give them life; often they are read figuratively, sometimes not.

Allowing time to consider and make changes during the build is useful to many makers. Claire Partington:

> My process is intuitive; you get on a roll and one figure leads to another figure – I have three or four things on the go in various stages and they change as they grow. That's the beauty of clay – you start off at the base and if the stance doesn't look right you can change it – the sketch is working the clay, as it changes a lot from the initial coil pot to the refining and even at that stage you can hack bits off and reposition. I don't work from a model – the figures are sometimes oddly shaped, but I like that about Cranach, who has inspired a recent body of work; his paintings are very distorted and stylized.

Process can also vary from project to project, as found by the author:

> Sometimes I know exactly what I want to make already in my head, so may not commit this idea to a sketchbook at all, if it's part of a series, for example, and I already know what clay to use and how it will behave. Other projects have involved making components and fixing them together after firing in assemblies that cannot be pre-planned and have to be worked out by trial and error.

Evaluation of the outcome will also help inform future planning as the assessment of previous work feeds into each subsequent piece. Patricia Volk:

> When I start a series it may not be clear until years after what sparked it, I am not always aware at the time, and when I start I don't know exactly what the outcome will be as I like to be able to change my mind throughout the making process. I'm adventurous, like to challenge myself and am always pushing forwards making new forms, thinking, 'What if…?' 'What happens if I do that?' 'What happens if I reverse that curve?'

This is why many choose to work in a series, as there will be a natural evolution as making progresses.

A way to address the limits of your thinking is discussed by Wanying Liang:

> Forget you are a ceramic artist. I always remind myself to forget that I am a ceramic artist when picturing the work in my mind before making it. Sometimes, merely recording your original idea honestly and sincerely instead of considering the possibility of making with clay all the time can help you extend the forms of ceramic art. Although some structures or shapes are extremely challenging to make using conventional clay, you just need to slightly change the unmakeable part or use other materials instead of clay to make those parts later. If you over think the limitations of clay at the beginning of your conception, your works may become too 'safe' or lack freshness. The works in my thesis show were considered to be almost impossible to make with clay, especially within a limited time. By designing and using a higher strength of clay and combining different building techniques, many problems were addressed, and the sculptures were successfully fired.'

And finally, Mark Draper has some sound advice about working in the flow:

> When things aren't going quite as well as I had hoped at the joining stage, it's important not to get dispirited. I down tools and go away. I'm always surprised at how much better things look than I had remembered when I return. It's important to recognize when you're tired and need to have a break. When you're 'in flow' one can forget how long you've been working and you're physical and creative energy will be winding down!

Wanying Liang's sketchbook.

Mark Draper, cardboard maquette and finished ceramic work based on the Barratt shoe factory, Northampton, 2020.

Chapter 3 – Inspiration and Planning

CHAPTER 4

PINCHING AND COILING

These basic techniques are the fundamental building blocks for many styles of work; this chapter introduces the pinching and coiling methods of construction, with examples of a range of forms that can be made in this way. The contributors explain how they approach these methods as an integral part of their making process and find rhythm in the stages of making that works in harmony with the drying time required.

PINCHING

Pinching is perhaps the most fundamental technique of all; it requires nothing more than using your hands to create a pot or bowl. The very first prehistoric pots were made in this way and it is often the initial technique shown to beginners. As a method it is flexible; a basic pinch pot can be added to in order to extend its size or change its appearance; it can also act as a building block for hollow forms. It suits any type of clay and is a good way of getting to know how the material feels and moves, how quickly it dries, how thin you can make it, and how stable it feels.

The technique is very straightforward: take some clay and pat it into a ball. Make sure it is a comfortable size for your hands; getting the ball as round as possible is helpful. Hold the ball in your weaker hand, or place it on a board, and push the thumb from your strongest hand into the centre of the ball to make an indent (but don't push all the way through to daylight!). If your thumb is not strong enough you can use something wooden to make the initial indent; the end of a small rolling pin or large paintbrush would work.

Keeping your thumb in the hole, place the rest of your fingers on the outside of the ball and gently squeeze the clay until you feel it give a little. Rotate the ball slightly and squeeze again, repeating this pinching action as you rotate the clay. The trick is not to squeeze the clay too hard but build the shape gradually in small increments. To keep it even, it often helps to close your eyes while you are pinching, so you can really feel the thickness without visual distraction. It can be a rhythmic, enjoyable process and you may want to take your time. Getting your thumb right into the clay where the side meets the base will make use of that thickness to add to the wall. You can change the shape by the position of your thumb when pinching, by bending the clay inwards over your thumb or outwards over your fingers.

To work out how thin you can take the clay you might have to push it too far – if anything goes wrong simply scrunch it up, wedge the clay and form it back into a ball, and start again. Sometimes trial and error is the best way to learn; this applies frequently to ceramics as it is about using touch and gaining familiarity with the hand. To form a flat base, you can drop it gently from a (very) small height on to a flat surface or push into the base from the inside, on to a board. If you would like a rounder base to add a foot ring later, rest it on a dry sponge while you work it to prevent it flattening on contact with a board or the table. It is fine if the pot is a little thicker at the base as the extra weight will help its stability.

If it cracks at the rim and becomes a bit ragged, this can be because the heat from your hands is drying it. A light spray of water as you go can help counteract this. Little cracks elsewhere can be worked with slip or water, depending upon the forgiveness of the clay; porcelain can be particularly tricky. You may have to reclaim and start again if the cracks are too serious.

◀ Paul Briggs, vessel from the *Windflower* series, 2020, height 23cm (9in).

PINCH POT TECHNIQUE

Pat the clay into a ball and make a hole with your thumb; keep your thumb in the hole and squeeze the clay a little, rotate the ball slightly and squeeze again.

Repeat the squeezing action, gradually forming a thick bowl; continue the pinching action until the walls have thinned out.

For a flat base, drop it on to a hard surface from a low height or push on to the flat surface from the inside of the bowl.

To refine the surface, wait until it has dried enough to hold its shape, then cross-hatch the surface diagonally from rim to foot using a serrated rib (also called a kidney).

To smooth the surface, work over the cross-hatch marks with a smooth metal rib (also called a kidney).

Trim with a craft knife to achieve an even rim (scissors can be used when the clay is soft).

To achieve a completely flush rim, grind it with water on a flat, rough surface – here a blank cardboard painting canvas is used. Chipboard or a concrete floor will also work well.

A foot ring can be fixed on by scoring and using joining slip (also called slurry). Foot rings can be made by forming a strip of clay into a loop and securing the join by scoring with slip.

A small functional bowl can be made quickly and simply using this method; it can be a good place to start for a beginner or a useful way to get to know an unfamiliar type of clay.

38 Chapter 4 – Pinching and Coiling

If the clay is very soft to start with, the pot might become floppy if it is worked too quickly. Letting it dry briefly at intervals during the making process will help it to hold its shape. If the top flares out too much, you can cut out a few evenly spaced triangles of clay out of the rim (pointing downwards) and join the edges together to bring the shape back into line. If you want a straight rim you can cut the clay with scissors if it is quite soft, or a sharp craft knife will do the job well at leather hard. If you prefer an organic look, you can deliberately squeeze the rim with your fingers to make the clay undulate or tear naturally.

For surface texture, many makers leave in, or even exaggerate, finger marks to leave evidence of the hand of the maker. If you want a smooth surface, you can start to work the walls with a rib at this stage. If you are scraping the outside of the pot, always support the pot wall from the inside with the opposite hand to prevent distorting or breakages from pushing too hard, and vice versa if you are scraping the inside.

Once the pot has dried to the leather hard stage there is a lot more you can do to refine the shape. It doesn't matter if your pot is a little chunky as a bit of rib work can tighten up the form. A simple way of refining the shape and getting a smooth curve is to first scrape it with a serrated (jagged-edged) kidney, or rib, and then a smooth metal kidney. First take your serrated kidney and scrape it diagonally from the rim to the foot and then cross-hatch these lines by scraping in the opposite diagonal direction. If you don't work diagonally but go straight from rim to foot or around the girth, it may not even out any lumps, and could even exaggerate them.

Next take your smooth metal kidney and use repeated scraping actions to work over the cross-hatch marks. Be aware of where the edge of the metal hits the pot – initially you might mark the pot but with practice, you will work out how to strike the pot at the correct angle and pressure to avoid this. If your clay is grogged, scraping will bring the grog to the surface and make the surface grittier. You might like this, but if you don't another option is to paint over it with slip or burnish it as a finish if you are not going to glaze; decorative options are discussed in Chapter 7.

The basic pinch pot form can make a great base for additions – it can be made taller by adding coils, or a spout, handle, foot ring or feet can be added to create a functional object such as a mug or jug. Detailed information about making handles and other additions can be found under 'additional techniques' in Chapter 6. To join pieces of clay, such as a handle to a pot, it is best if they are at the same stage of dryness, ideally at the leather hard stage. If one is much softer, allow it to dry a little while the other is wrapped in plastic. Once they are similar in feel, work out where they will join and score that point with cross-hatch marks on both pieces. Add joining slip, a runny version of the same clay also known as slurry, and push the pieces together so that the slip oozes out slightly. When pushing, be careful not to push too hard and distort or break the pot – put your hand on the inside of the pot to support the wall and push against that. The oozed slip can be gently cleaned away with a damp sponge or damp, soft brush.

The same method but a different aesthetic: a porcelain pinched pot with surface left unrefined, finger marks showing, rim left untrimmed.

Supporting the bowl on the inside while refining the outside with a metal rib; this support is important to avoid damaging the pot at the leather hard stage.

A pinched pot can form the basis of any number of pieces; with a handle and snip it becomes a jug. The snip was made from a flat piece of clay, cut and formed into shape while soft, then joined when leather hard. Handles are discussed in Chapter 6.

Joining slip can be made by adding water to bone dry clay, letting it soak then stirring and sieving if required. If there isn't any bone dry clay to hand, with a bit more effort, just adding water to small lumps of raw clay and working with a stiff brush will eventually yield a good consistency. The best joining slip comes from the slops in the tray of the potter's wheel when someone has been throwing – it is always a smooth consistency.

For sculpting purposes, two pinch pots joined together at the rim can make a hollow egg-shaped form, which can be used as a base for a sculptural form. Always make a hole in a closed form to allow air to escape during the bisque firing or your piece might explode. An example of this way of working to create a head is shown as a sequence in Chapter 5.

COILING

Coiling is a brilliant technique for building gradually and adding some scale to your work as it can be used to build very large pieces – your only restriction is kiln space. That does not mean you cannot make exquisite small works, and although this is a superb technique for making pots, it is easily adapted for sculptural works or to combine with other processes. If you have time, it is well worth finding footage online to see how beautiful coil pots are made by women in Burkina Faso and Nigeria (Africa) and Lombok (Indonesia); their skills are very deft and are often passed down the female line.

The beauty of coiling is that it is an additive process so you are able to control the shape of your work as you progress: some planning can be useful before you start and could include making a profile to help check the shape as you go. This is simple to do: find a sheet of cardboard from a box that is tall enough for the pot you want to make; don't forget to consider kiln height and shrinkage for your final outcome. Draw the profile line of the right (or left if you are left-handed) side of the intended pot in the centre of the cardboard. Cut along that line and discard the section which represents the pot, using the remaining cut cardboard as an outline to check on your progress as your pot grows. This method can be especially useful for a very curvaceous pot or for accuracy in the early stages when it is hard to envisage the finished shape.

There are several ways to approach coiling, and, like most making methods, there are variations, but the basic idea is that lengths of clay are formed and coiled around; hence children often call them 'sausage pots' or 'snake pots'. As they are built upwards, the first consideration is the shape and size of the base. A coil pot need not be round; the method works for any shape. Ensure the base is the right size, bearing in mind the shrinkage of your clay, as you cannot change it once you get going. For accuracy, you could use a template for cutting out the base; there will often be something suitable around the house you can cut around, such as a plate or plastic lid. If you have an unusual shape in mind you could make a template out of cardboard.

In terms of tools, you need very little to get coiling – a rolling pin, cloth (such as a piece cut from an old pillowcase), a craft knife, wooden board (round is best) and if available a banding wheel is invaluable. You may need metal ribs later in the process and some makers like to use a hairdryer or heat gun to speed up the drying process.

Start by making the base; this is a 'slab' and will be featured further in Chapter 5. Lay out the cloth and make sure there are no folds or creases as they will mark the clay. Get a big enough lump of clay to roll a little more than you need for the base – there might be some trial and error judging the size, but you will become better as you gain

A profile is a good way to keep a coiled form on track if there is a specific shape in mind; draw the intended shape on to the card (allow for shrinkage).

Cut along the line and discard the piece that represents the form. The profile is then held against the form at every stage during the build to check that the shape is correct.

To roll out a slab, first put down a cloth and press the clay into a flat shape. Using two equal wooden lengths as guides while you roll will help keep the slab even in thickness.

Using a wooden rolling pin, roll the clay out, turning the slab over during the process to keep the compression even on both sides.

Choose an object to act as a template to achieve the shape and size you wish to start with; place it on to the slab and cut around it with a craft knife.

experience. You might want to push the lump into a flat shape to make it easier to roll – do this standing up and lean your weight forwards as you push; there is no need to hit it hard. To keep your rolling even, you can use two wooden lengths of exactly the same thickness as guides. Place one on either side of the cloth, once you have made the initial flattening, as you will gradually build up to pushing the rolling pin along them like tracks to get a perfectly even slab.

Roll the clay out using a wooden rolling pin, a little at a time, turning it over occasionally to get the compression even on both sides. The process is a little like rolling pastry for a pie and once you have rolled enough to reach your wooden guides it will be ready. An average thickness for a slab would be around 1cm (half an inch) thick, depending on the size of your piece; change the thickness of the guides to change the thickness of your slab. If your base is a little thicker that is fine; the extra weight can help to stabilize the base of the form, but if you roll it too thinly there may be difficulty joining the first coil.

You may see a little lump or two when rolling, which are air bubbles. This will be because the clay isn't wedged thoroughly enough; if there are lots of lumps, form the clay back into a ball and give it a really good wedge, which should solve the problem. If there are only one or two pesky bubbles you can pop them by rolling the rolling pin back and forth over the bubbles, which should encourage them to pop. Once popped, roll a little more to even out any craters. If they are really stubborn, pop them with a pin and mark with a cross to ensure they do not reform.

Remove the slab from the cloth and place it on a wooden board as it is better to cut the base on a hard surface. Once you have done this, consider putting your maker's mark (and maybe the year) underneath as it will be more difficult to do this later on in the build. Now for the coils – you can make a large number and wrap them in plastic to keep them damp or make a few as you go. Most commonly they are made by hand but if you have access to an extruder you can extrude perfectly even coils: always do them in bulk and clean up straight away before the clay dries in the mechanism and makes cleaning arduous.

Making coils by hand is a skill which improves over time so do not be discouraged if they are bit uneven initially as they will still be usable. Take a lump of clay – start small if this is new to you – and by squeezing with your hands, form it into a thick sausage shape. Then, using a flat surface such as a board or table, or your plaster bat, place the clay on the surface. Place the tips of your fingers on to the coil at the centre. Push gently backwards and forwards to get the clay rolling and forming into a rounder sausage. As you roll work your hands from the centre, moving away from each other to the edge and back to the middle again. Getting the pressure right will increase the length of the coil until it is the size you need. That is the tricky part and again, is learned best through experience; keep going and you will start to feel when it is right.

If your coils are flat, you are pushing down too hard and squashing them rather than rolling them. You will also need to be gentler if your clay is soft. Many makers find it useful to taper the ends of the coils at the point of making, which smooths the

Place the coil on to the slab and smear the end of the coil to fix it firmly on to the slab. Wind the coil around, building up into in the shape you require.

Blend the coils to fix them in place, using your finger or a tool, supporting the other side of the clay wall with your opposite hand.

joining process from the end of one coil to the start of the next. Some makers use larger, flatter coils for building that are almost rectangular if you cut them in section – a quick internet search will bring up fascinating footage of a number of variations.

Different makers have varying approaches for joining coils using scoring, slip, both or neither: it depends how forgiving the clay is. Some like to join just the first coil scored with slip; some prefer joining them all with slip – be aware that this adds water and softens the clay, so allowances need to be made for extra drying time. Clays with added grog are often used without scoring or slip and build at a faster rate as they are drier and therefore more supportive. There are always slight variations in the way that makers approach all aspects of technique, with adaptations made along the way to save time or to address a specific issue.

With your slabbed base on a wooden board, then on a banding wheel (if you have one), and with some coils ready to go, you can start to build the form. Place the coil on the slabbed base, smearing it at the end with your finger or a tool to fix it in place. Wind the rest of the coil around the base and carry on upwards. When it runs out, smear the end to secure it in place. You can add more and build the form up a little higher, checking with a profile if you are working to an accurate shape. Blending these coils is the next step – at this point some makers decide not to blend the coils either on the inside or on the outside. This can depend on whether the work is sculptural or functional. Blending the coils ensures a solid wall and allows for 'fettling', which is the act of refining the surface with ribs and a sponge, and is required for a smooth finish, or if you wish to use it as a base for further additions or decorative processes.

Blending can be done with your finger or a tool. Whatever you use, it involves smearing a little clay from one coil on to the next, to secure them together and get rid of the line you see between each one. You can smear the clay upwards or down, but it is best to be consistent and move in one direction only. You will find you get into a rhythm, which may show in your marks; you may choose to keep them to show the hand of the maker. At this stage you can start to smooth the wall inside and out with a rib – wooden, metal or plastic ribs all work well. Keep building upwards in this way, checking your shape is satisfactory before you commit to blending the coils. If you are using grogged clay you will be able to build faster; if you are using softer clay you may need to pause to let it dry out a little before adding more coils to avoid warping or collapse.

To hurry the drying along, many makers use a hairdryer or heat gun to blow hot air on to the clay. Be careful to ensure that this is done evenly by rotating the work and spending equal time on the inside and outside of the walls. Heat guns can become very hot at the end, so care is needed to ensure you don't accidentally touch it, as it will stay hot for quite some time after being switched off. When you resume building, if you find you are adding soft coils to a form that is heading

towards leather hard, join the first new coil by scoring with slip to fully secure it. This ensures a well-anchored join that will not come apart during the drying stage.

Making a coiled form over several days or during weekly sessions will not be a problem if it is wrapped completely in plastic to ensure it does not dry out between making sessions. Do not wrap the wooden board in with the work as it will go mouldy and the wood may take more moisture out of the clay than you want. If you are leaving it wrapped for a while you can pop a damp sponge inside the form to keep the atmosphere

Jo Taylor, *Vari Capitelli viii* work in progress: the base of this piece was made by rolling a flat slab and cutting around a fluted side plate to achieve a scalloped edge. Coloured stains were wedged into the clay prior to starting. The first coils were added and blended straight to the base without scoring as they were at the same stage of softness. New coils are rolled and added to build up the wall gradually, following the scalloped edge.

The next soft new coil is joined by scoring and adding slip as the first section of wall has dried a little: this will ensure the join is firm throughout the drying, shrinking and eventually the firing process. New coils are added, then blended with a wooden tool inside and out to join them firmly, then the wall is refined for the first time with a flexible rib, such as an old credit card.

As the pot grows and the lower level becomes leather hard, further refining can be made to the wall using first a serrated, then a plain metal kidney to achieve a smooth finish. The shape of this pot was formed by eye; as coiling is incremental, you can alter the shape until you're happy, then blend the coils and it is set.

The scallop outline was exaggerated at the top of this form; the voluptuous shape was achieved through building up coils, contrasting with works in this series, which used the potter's wheel throughout the build. To complement the curves, a simple thrown neck was added to finish the piece before it became too tall for the kiln.

Flourished additions were made by hand and on the wheel, and then added at leather hard stage. This work was constructed on a board and moved to a kiln shelf to dry, in order to avoid lifting it at the bone dry stage; the whole piece was dried slowly to avoid cracks and breaks before being fired.

moist over longer periods. The best plastic to use is the clear type used for covering new and dry-cleaned clothes. This is often discarded, so it might be worth asking around to get a small supply that will last for a while. When you unwrap your work to continue coiling, check the hardness of the clay at the point you will join the next coil; if it is on the dry side it's worthwhile to wet the rim with a damp sponge to soften it before scoring and adding slip to secure your new coil. As you build you will get a feel for the clay as it dries from soft towards leather hard. If it feels like it is getting too dry at any point, especially if the weather is hot, a light spray with water will counteract this.

'Paddling' can be useful in helping iron out any lumps and bumps as you build, and it also compresses the clay, adding strength and support. Paddling is the act of hitting the clay with a flat wooden spatula that you can buy or 'borrow' from the kitchen, or you can simply use any available piece of flat wood. It will make a slapping sound; start gently and build up until you feel the clay is compressing as required.

As your work becomes leather hard there are several processes you can apply to get the shape and surface a bit sharper. This 'fettling' can be approached gradually as you build or employed at the end in one go. Extensive refinements can be made to the surface with a serrated, then smooth metal kidney, in the same way as described with the pinching method; that is, cross-hatching diagonally across lumps and bumps and then smoothing. Your wall will probably be quite thick, so shaving off a few millimetres of clay to get a smooth surface will not be detrimental, and your shavings can go into the reclaim bucket or used to make joining slip (or slurry). Once you have refined the shape, you can wipe over the surface with a damp sponge but be aware that it can drag grog to the surface. If you prefer a smoother surface, you can use a rubber kidney or the end of your finger.

Once your form is complete, there are many directions it can take. If it is intended to be a pot, give some thought to the top and bottom before it is finished. Rims and feet frame what happens in between and often have a relationship, such as a similarity in thickness or shape to add balance, and a definitive start and finish to the form. Adding a decorative coil at the rim and foot can accentuate this. Another consideration would be to add a slight undercut to create shadow and lift the form slightly off the ground. This can be achieved by using a sharp craft knife to trim around the base at a 45-degree angle.

Building the form might be just the start of your project; for example, if it is intended to be functional it can become the basis of a vase, jug, mug, cutlery drainer, colander, dish or bowl. You can add a foot ring or feet, handle, snip, or spout or you can cut holes into it. As well as starting with a slab, you can add coils on to a pinched or press-moulded base or combine them with pinched hollow forms to make an abstract or figurative sculpture.

CONTRIBUTORS

It is fascinating to see how each maker has honed their process to find the most suitable way of working with their chosen construction techniques. Here they discuss how they manage their working space and energy and how they approach the drying of their work.

Patricia Volk:

I start by extruding six bags of clay into coils (2cm or 1in diameter) and wrap them in plastic so I can really focus on building and won't need to stop to make more. I can get a bit hyperfocussed and will work to exhaustion! I use Scarva ES20 as it is quite fine, but lightly grogged to help build strength at this scale. I build in tandem so I can work on one piece while another is drying naturally; I prefer to let them dry this way as a heat gun can be a bit concentrated, so can be uneven.

Once I have coiled the form, I spend time refining the surface, which can take several days and will remove quite a bit from the wall, which starts at around 1.5cm or 0.75in thick. I have to rough the surface up in order to make it smooth, so first of all I work diagonally with a toothed metal sculpting tool and a serrated kidney. The next step is to smooth the surface with a thin metal kidney, then remove more clay and refine further using a surform. The final step is to smooth again with the thin metal kidney: I like a little texture to the surface which comes from using the kidneys – it is needed at this scale.

It is important for the form to have some visual 'lift' at the bottom, so I often make an undercut, where some of the form is jutting out over thin air – to keep it correctly in place I will place a support underneath during

Patricia Volk's studio: a large batch of coils have been extruded and wrapped in plastic, in preparation for the build. A narrow-based form has just been started on the banding wheel.

To the rear, the narrow-based form has had coils added and is now flaring outwards; an elliptical form has been started in the foreground. Both forms have their rims wrapped in plastic to keep them soft for joining the next coils, while the bases dry and firm up.

Three forms are now being built in turn to allow each to dry enough to support the next set of coils. The elliptical form has undergone some refinement to the surface. Various works in progress are in the background.

The third form will become the base for the first narrow form; they are put together to check they work visually. The elliptical form now has an overhang, the weight of which is supported temporarily while it dries enough to support itself.

Chapter 4 – Pinching and Coiling 45

Both works continue being built upwards; once the coils have been blended, a serrated kidney is used to make the surface even, yet still rough at this point.

The elliptical work has now dried enough that the support for the overhang has been removed; the top of the form is finished. The work behind is nearing the end of the build phase.

The surface of both works have been refined further with a smooth metal kidney. They have been carefully and thoroughly dried, and fired to 'bisque'.

Once all of the works in the series have been fired, they are first primed, then painted with acrylics before a final layer of varnish is applied.

46 Chapter 4 – Pinching and Coiling

Patricia Volk, *Evolve*, 2019, height 78cm (31in).

Madoda Fani, work in progress, demonstrating the use of large, flat coils.

the drying stage. Equally, I might judge that a piece needs something at the top, as I work out the balance at leather hard, and use leftover coils to make smaller pieces to use as additions. I don't join them at this stage and leave the decisions until post-firing so I can change my mind; the little pieces help to fill up the kiln. All pieces are made with holes in so I can assemble and join them post-firing using rods, expanding Rawlplugs and glue.

Madoda Fani also maintains several consecutive works in progress:

> I start with a flat base; the shape of the flat base depends on what shape I want my piece to become. Once I am happy with my base, I will put a coil on it. A coil is clay rolled like a sausage; the difference with my coils is the size, because I make them big. After making the coil, I will make it flat – about 10cm (or 4in) across. I always work in series of three pieces at the same time. The reason for this is because after I put on the first coil, I have to wait for it to dry before putting the second coil on top of it. So, I put the second coil on the second base and move on to the third one. By the time I finish with the third one, the first one will be ready for the second coil. I will continue doing this until I finish the piece. During the construction I always cover the bottom part with plastic, so that it doesn't get dry. When I am done with the construction I will start with the carving of the piece.

Over time Euseubio Sanchez has adapted his process to support the concept of taking a line for a walk:

> I have learned from kiln disasters, coils coming apart; that the clay wants to be blended together and has a memory. I've tried lots of clay – it needs to have some grog – and often use white porcelain stoneware with added grog. I have had to resolve all of this to get to where I am now, trial and error, problem solving at every step, and the

Eusebio Sanchez using a standard extruder to create a batch of coils, ready for the making process.

Using a scoring tool; each coil is carefully joined to the next by scoring and adding slip.

Long coils are crucial for the process of 'taking a line for a walk'; the inside of the piece is worked until smooth.

Two works are in progress simultaneously allowing one to dry and firm up while the other is worked upon. Both are built on kiln shelves to avoid handling the fragile raw work.

Eusebio Sanchez, *Coil Journey – Anatomy of a Process*, 2019, tallest height 52cm (20.5in).

48 Chapter 4 – Pinching and Coiling

Jo Taylor's studio: oval coil pot made from orange clay, with thrown feet and beading added to the rim and base to define the edges.

Starting to build up the surface by attaching additions by scoring with slip: some are extruded and altered, some are hand formed.

process has evolved. I use a little fork to score cross-hatches and use slurry between each coil, which is then blended on the inside but dried a little first, so it doesn't distort the coil. I use very long coils to enable me to three-dimensionally build a sculpture; I use clay straight from the bag into an extruder to make very soft coils. I made an extruder gun to make the coils very long – it is an adapted mortar gun from a hardware shop and is still going strong after three years, which is very money saving! I make my own dies.

For the author, coiling is a means of creating forms that are not round:

I use throwing as a method in much of my work, but some shapes cannot be achieved on the potter's wheel, so coiling has been a useful method by which to vary the shapes in the *Vari Capitelli* series of sculptural vessels. I was keen to make an oval variation, so first of all mixed orange stain into the clay and then built a straight-sided oval pot using the coiling method, before adding thrown feet underneath to lift the form off the ground. I then made 'false' hand-built feet that fixed on to the rim, to look a little like ball and claw feet you might get on a roll-top bath. Finally, I added extruded, thrown and hand-built additions to give some flow and drama to the piece.

I returned to coiling for the voluptuous shape I had in mind for the purple clay vessel *Vari Capitelli viii*. Inspired by Piranesi, I had been looking at his architectural etchings and had seen scalloping occur in several images so wanted to try it. For the base I cut around a scalloped IKEA plate and built from that template, adding curves to create a waist and made separate curved shoulders at the top of the pot. I was unsure how to resolve the neck and felt it best to keep it simple, throwing and fixing a round neck to bring a simple conclusion to the complexity of the form.

Chapter 4 – Pinching and Coiling

Finished piece at the raw stage; the additions have added energy and direction. The largest additions were placed first and the smallest pieces added last.

Jo Taylor, *Vari Capitelli iii*, 2019, height 41cm (16in).

Lynda Draper, *Still Life*, 2005, height 26cm (10in).

50 Chapter 4 – Pinching and Coiling

Combining techniques helps to achieve the tactile surface and expansive structure of Lynda Draper's sculptural work: 'I predominately use paperclay using a combination of pinching and coiling hand-building techniques, depending on the structure of the work.' The pinched form started as a way of using time while slabs were drying, but became more significant for Paul Briggs:

Paul Briggs begins a pinched form using a flattened sphere, making the hole in the flat side.

Reaching into the base of the pot, pinches are overlapped in a spiral towards the rim.

To keep the rim even, it is regularly moistened then compressed on to the board.

Turning the form upside down, a foot is created by pinching around the base.

Chapter 4 – Pinching and Coiling

Pinching continues to enlarge the main body of the pot from the base upwards.

Thick ridges are left unworked for the creation of decorative elements later on.

A heat gun or hairdryer can help to stiffen the foot at this point, to allow it to stand upright.

Pinching around the thinnest areas will help expand the shape a little more.

52　Chapter 4 – Pinching and Coiling

If any areas to be worked become dry, a wet paintbrush can be used to add moisture.

The clay ridges are pinched into sections for creating decorative elements in line with the foot ring.

Plenty of thickness was left in the rim to work in decorative elements, to enable it to balance with the foot.

The finished work embodies the rhythm and patience with which it was made.

Chapter 4 – Pinching and Coiling

The finished work embodies the rhythm and patience with which it was made.

My vessels are pinch formed, no subtraction or addition of material; they are expanded. This makes a 15cm (6in) pinch pot a midsize piece; often we do not see pinch pots more than 7.5–9.5cm (3–4 inches tall). Unlike most pinch pots, as opposed to pushing my thumb into a round sphere, I flatten one side, or centre one side, of the sphere. I use that to guide my thumb into the centre of the clay, pinching all the way down to the bottom, then hand turning the clay upwards just as one does when throwing. This makes large pinch pots possible, though it is labour-intensive. Paulus Berenson discussed this technique some years ago in his book, *Finding One's Way with Clay*.

People are often surprised to hear that I consider myself first and foremost someone who works with slabs. Pinching has always been what I did to find quiet time in the studio, or what I did while my slabs were getting stiff enough to use. Only recently has the pinching taken on more conceptual, or should I say, philosophical content. Usually, my philosophical musings have always come out in the form of slab-built work. Given that slabs take an awful lot of planning, construction and waiting for them to stiffen, at various times in my circuitous journey, pinch pots have been the one method that I could do if I had one or two hours of time. It was something that I could do and not have to come back to or cover it with plastic or spritz it or trim it.

He offers the following advice on how to get the most from this process:

One of the supplies that I always ask my students to bring is patience. Transforming is a slow process and if it is to be done well it must be a mindful process. I still have not gained enough fluency over many years to be able to pinch something well without paying close attention. I do not recommend this technique for someone who isn't able to slow themselves down. My students who work diligently and mindfully are able to make great strides with this technique in only a few weeks. It really is a beautiful feeling to pinch a piece without addition or subtraction from one ball of clay and expand it to 12.5cm and 15cm (5in and 6in) forms. And then pinch back into it with a low relief or medium relief pattern – it's very satisfying, every time it's very satisfying.

Paul Briggs, *Windflower*, *Unfurling Frond* series 2020, height 18cm (7.25in).

Chapter 4 – Pinching and Coiling 55

CHAPTER 5

SLABBING AND PRESS MOULDING

Slabbing is the process of using rolled sheets of clay to create forms; it is a very flexible technique as slabs can be used at both the soft and leather hard stage. This chapter examines the versatility of slabs and the use of different types of press moulds, used mainly for creating functional platters and dishes. In contrast, the contributors share how they have honed the slab-building process to suit the construction of their impressive sculptural works.

This process is used to make tiles and is how straight-sided box shapes and cylindrical pot forms are created. Many makers use this method in conjunction with figurative sculpture as when soft, a slab can be manipulated to show undulations and can take on impressed texture, to mimic fabric, for example. A slab can be formed into a shape by using a mould and this technique works well for different sized pieces. Complex sculptural structures can be created with slabs and it is a method that combines well with others, such as coiling. Texture and coloured slip can be added before construction; decorative options are discussed in detail in Chapter 6.

Tiles are simple to make, but they can transform an uninspiring section of wall inside or outdoors, for example, to create interest as a splashback behind a sink or hob. Although it is possible to measure and cut tiles using a ruler and set square, using a tile cutter offers an easier and more consistent outcome. Purchased in various shapes and sizes from a supplier, they last for a long time and ensure continuity of shape and size. The only variable is the thickness, which is controlled by the maker in the rolling out stage.

If you are fortunate enough to have access to a slab roller, you will be able to make large, perfectly even slabs without the labour of using a rolling pin. Alternatively, you can roll out slabs using a rolling pin and cloth in the way described for making a base in the coiling chapter. Accuracy of depth is important to keep your tiles uniform, so use wooden guides to help the slab stay on track. Guides are wooden lengths of

Making a tile: place the slab on to a board and push down firmly with the tile cutter.

Remove the excess clay and put to one side.

Release the tile by pressing the big button – this tile has rice rolled on to create surface interest.

Mark Draper, work in progress based on Sir Thomas Tresham's Triangular Lodge.

equal size – they can be sourced from a large DIY store or cut to size if you know someone who works with wood. The length is not too important, but the depth is crucial and makers often have several sets of guides with different depths for working at various scales.

Once you have rolled out your slab, peel it away from the cloth and place on a wooden board ready for cutting; it is easier than trying to cut with your slab on the cloth. Similar to making cookies, it is economic to get as many tiles from one sheet as possible. Place your tile cutter on to the slab and push down evenly on the edge of the metal frame; you might want to stand up and lean over to use your weight to push down as you need to be firm. You will feel it give as it cuts through the soft clay, then stops when it has cut through to the board. Next, use the upper part of the metal frame to pull the whole cutter and tile away from the slab. Have another board ready for the tile and push the ball at the top of the cutter to release it gently on to the fresh board. Keep going until you have enough and then cover the tiles with another board so that they dry evenly on both sides, to prevent warping.

MAKING A CYLINDER

Roll and cut the clay; a set square will help in achieving accurate angles.

Ensure there is enough length to create a large enough cylinder – a tape measure can be helpful.

A tube makes a great support structure – a newspaper sleeve will help it to slide away from the form later on.

Score the edges where there will be a join and add slip (or slurry) which acts like glue.

Press the edges together and carefully wipe away any excess slip using a damp sponge or brush.

For a smooth join, use a flexible rib, which can be an old credit card or similar.

Place on top of a slab and cut around to create a base. If the shape is a little irregular, make a mark so you can line it up later.

Score both edges and join with slip. The scoring tool can be bought online or from a pottery supplier.

Wipe away any excess slip and smooth the join with a flexible rib.

Chapter 5 – Slabbing and Press Moulding **59**

MAKING A BOX FORM

Measure and cut your slabs; score the edges and ensure all are leather hard, ready to assemble.

A bevelled, or chamfered edge, makes a good join – it can be helpful to use a wire bevel cutter to achieve this.

When joining slabs, in addition to scoring and slip, a small coil will help to reinforce the join.

Staying with soft slabs, the next shape to explore is a cylinder, made by wrapping a slab around a tube. By adding a base, you can have a pot or vase; add a handle for a mug, a snip for a jug or it can be taken further into a tea pot or as a component for sculpture. Before you start, a little planning will help you achieve success: first, source a cardboard tube or a section of plastic pipe to support your structure. Clay will stick firmly to plastic, so if you are using a piece of pipe you will need to make a newspaper sleeve joined with masking tape, which can slide off easily so that your pot and the structure can part ways. It is important to remove the clay from the support structure reasonably promptly; if you leave it to dry on the structure for too long it can shrink and cling too tightly to remove without damage, or it could possibly split.

Take time to estimate the size of your slab, as the circumference of your pot can be deceptively wide. Wind a tape measure or a piece of string around your tube to help measure the length you require. Make sure you have enough clay to make the whole slab in one go; trying to patch up a slab is not advised as it may show up in the firing. Think about how you will manage the join where the slab wraps around on itself, which will need to be slipped and scored securely. An overlap is a strong join, but it brings the problem of a double thickness. There are different ways to resolve this: many will make a feature of the join, using it as a place to add a decorative element, like a textile seam with an ornamental edge. Joining with a bevelled or chamfered edge can resolve the thickness issue; this is where edges are cut at an angle diagonally to make them overlap neatly. Alternatively, you can spend time scraping away excess clay at the leather hard stage to reduce any thickness.

Rolling slabs and leaving them to dry to the leather hard stage is the best approach to creating straight-sided objects, from boxes to many faceted sculptural works. Once partially dry, clay becomes stiff and supports itself well; it is also easier to handle as it does not show finger marks and sharp edges and angles can be cut easily. A box form is straightforward as long as your measurements are accurate and you are clear about how the edges will join. If you bevel, or chamfer, all the edges to 45 degrees before joining, your sides will be even; if you join edge to edge at 90 degrees, some will be shorter than others. To strengthen any joined edges, smear a small, soft coil of clay into the inside of the join, which is especially helpful for supporting larger scale forms.

Smooth the coil into the joint to strengthen the area, and repeat with each join in the same way.

Continue to add each facet; the assembly can be quite quick if everything is prepared first.

This box will be a planter for outdoors – some edging has been added to balance the rim and base visually.

Drainage holes are created using a hole cutter, which can be bought online or from a pottery supplier.

Feet are added for visual lift and drainage; they are hand-formed balls with a hole cut through to aid drying, secured by scoring and slip.

Hand-formed lug handles are added for visual interest, with some surface decoration made from thin coils.

Chapter 5 – Slabbing and Press Moulding **61**

PRESS MOULDS

Press moulding is a way of using a slab, pressed into or over a shaped surface to take on its contours. The surface can be a plaster mould, bisque-fired clay or a wooden, paper or fabric mould. The clay can be pressed into a hollow form – a 'slump' mould or pressed over a form – a 'hump' or 'drape' mould. It is an efficient way of making several repeat pieces for use as tableware, or to construct a sculpture that uses several repeat elements, for example, body parts or facets of a building. Press moulding is related to the industrial processes of slip casting, where liquid clay is poured into plaster moulds to form a clay 'skin' and the use of a 'jigger and jolly', which is a machine that combines a mould with a wheel. Both methods are used to produce commercial tableware and are how repeated forms are achieved in a factory setting.

PLASTER MOULDS

Moulds can be purchased ready-made or you can make your own from plaster; complex forms require specialist skills, but basic shapes can be cast in a straightforward process to create a 'drop-out' mould. You will need a 'model' to cast from; something simple like a cereal bowl or pudding basin is a good place to start. It is important that the shape has no undercuts, which would prevent the model from being able to 'drop out' of the finished mould. Make sure your model will easily release from the plaster by coating it in soft soap, or model-releasing agent; some makers use petroleum jelly or household liquid soap.

You will need a surface upon which to make the mould that will enable it to release; those frequently used include glass, wood or a rolled-out slab of clay. Place your model upside down on to the surface, that is, rim side down; some like to secure it in place with a little clay under the rim. Make a wall, or 'cottle', around it to contain the plaster – it is recommended to leave at least 2cm or an inch between model and wall. The wall can be made from a stiff plastic sheet, which will need firmly securing in place by taping around it or tying with cord. To anchor it in place, a coil of clay is smoothed around the outside, plugging any gaps. Some use a rolled-out clay sheet; remember that any clay contaminated with plaster cannot be used to make new work as the plaster causes explosions in the kiln.

Wearing a respirator mask and protective gloves, measure out the plaster and water to the manufacturer's recommended ratio, then carefully add the plaster to the water. Mix gently with your hand to achieve an even consistency; skim off any bubbles and discard. After a short time, you will feel the plaster start to thicken; pour it slowly and evenly on to your model and leave to set. Once it has set, dismantle the cottle and remove your original model, allowing the mould to dry thoroughly before use. Any rough edges can be taken off using a surform. Clean your workspace thoroughly afterwards so that new clay is not contaminated with plaster.

To further your skills in this area, finding relevant reading matter or attending a course will help you progress to working with more complex forms, help you understand how to plan your approach and enable you to discern what equipment you will need. Moulds are often made using lathes and whirlers to achieve accurate shapes; instruction about mould making is often found alongside information about slip casting.

A large plaster mould for making platters: this shape is very easy to press into; deep moulds are more challenging.

ALTERNATIVE TYPES OF MOULD

While plaster is the most commonly used material for moulds in industry, teaching and for individual makers, a range of other materials can be used as a simple mould. If you know someone who can throw on the wheel, it is straightforward to get a simple round bowl or plate mould made. The inside shape is the important part, as that is where the slab will be pressed. It is best if the mould is thrown quite thickly so that it is more porous and robust. It will need to be bisque fired to around 1000°C (1832°F), then it will be ready to use and should last for a long time.

Bisque moulds made on the potter's wheel; thrown to be much thicker than a pot in order to make an absorbent mould.

A china dish, bowl or plate can be used as a mould: line with clingfilm, paper or fabric.

The lining ensures the clay can be released once it has dried and shrunk a little.

An existing glazed ceramic dish or platter from the kitchen cupboard can be used as a mould, provided it is lined so that the clay will not stick and can be released. Cling film can be used as a liner; it will slow the drying process slightly and can be fiddly to get into place initially, but it is readily available and adheres to the shape well.

A cardboard box makes an effective mould if you have one the right shape and size.

Chapter 5 – Slabbing and Press Moulding

Draping clay into fabric can create a less formal shape; this is just one way to suspend a piece of cloth!

Prepare a slab; you may wish to add texture or colour first – these options are discussed in Chapter 7.

Place the slab on to the fabric and leave to dry to leather hard before handling.

A very simple frame can be made from newspaper secured with masking tape and placed on a board.

A slab can be placed on to the frame and gently encouraged to take the shape with a damp sponge.

A cardboard box can be used as a slump mould, or cardboard can be cut, folded and joined with masking tape to construct a shape. Bear in mind that it will not be robust for repeated use and may get saturated and distorted, but it can be fun for one-off pieces. A soft slab can be placed into a fabric hammock to achieve an asymmetrical and rounded shape, which will require the addition of feet or a foot ring once leather hard for it to become stable. Hammocks can be made in a number of ways by pegging fabric to a stable structure; the example in this book shows fabric pegged to the edges of a large bowl. Using folded or scrunched-up newspaper secured with masking tape is a cheap and easy way to make a slump mould; this method has the advantage of flexibility of scale, although like cardboard it will not be robust for repeated use.

Wooden MDF moulds in an array of shapes and sizes can be purchased online or from a pottery supplier.

A slab is draped over the mould, then gently pressed with a damp sponge to take on the shape.

The edges are trimmed and the dish can be turned up the right way to be decorated if required.

An upturned balloon can be fun to experiment with; this one had thick, coloured slip added in layers.

Once the slip had dried to leather hard, the balloon was gently removed: this is the resulting form once fired.

MDF hump moulds can be bought from your supplier or they can be made for your specifications if you know someone with woodworking skills. They can be a useful mould for straight-sided, as well as round or oval forms, and should last well. Balloons can be a fun way of experimenting with a hump mould – place the balloon upside down into a pot to anchor it and build clay on to the round end. It is best to let it deflate slowly to release the clay as popping it carries an obvious risk to the work. This is not an exhaustive list, so if you can think of another way of making a mould, why not give it a go!

Chapter 5 – Slabbing and Press Moulding 65

Press-moulding technique

To use any of these press moulds, first roll a slab using wooden guides, a dry cloth and rolling pin, or a slab roller if you have access to one. Carefully place the slab on to the mould, and gently start to apply pressure to encourage the slab to take the shape of the mould. Many makers use a damp sponge to press gently, so that there will be no finger marks in the clay where pressure has been applied. Build up the pressure gradually to allow the clay to adjust to the shape it is taking. Flat forms are very straightforward, but deep moulds can be challenging, and getting a feel for the pressure may take trial and error. Make sure you have pressed into any recesses by feeling whether or not the clay still has any give and springs a little to the touch: if it does not move you have reached the edge, corner or recess.

Trim away the excess clay along the edge with a knife, and if you want to avoid sharp edges after firing, run along the rim with a damp sponge or wet finger to smooth it out. This is particularly important if the work is intended to be functional

PRESS-MOULDING TECHNIQUE

Roll out a slab on a cloth, using guides to ensure an even thickness.

Make sure you have rolled enough clay to fill the mould with one sheet; this may take a bit of trial and error.

Gently place the slab on to the mould, and put them both on to a banding wheel.

Using a damp sponge, very gently press the clay into the mould, a little at a time, as you rotate the banding wheel.

as it will make it less vulnerable to chipping or cracking when used regularly. If any areas need smoothing out, use a rubber kidney or your fingertip to produce a sleek finish. Be aware that excessive working with a damp sponge will bring any grog in the clay to the surface.

This may be all you need to do at this point, depending upon your decorative choices. Slip or sprigs could be applied now and you can work with the clay at this soft, responsive stage or leave it to dry a little until it is leather hard. To release the form from the mould, allow it to dry a little and shrinkage will occur naturally, making it easier to handle and remove. Moulds can take on quite a bit of moisture if used continually and may benefit from a short period of drying out; just leave the mould for an hour on top of a warm kiln, in the sunshine or near a radiator.

Once there is no more give in the clay you have reached the edge of the mould; carefully trim the rim.

Smooth the rim with your finger, or a rubber kidney, which will make it less vulnerable to chipping if used regularly.

Once leather hard, the form should release easily as it shrinks gradually throughout the drying process.

Chapter 5 – Slabbing and Press Moulding

Combining techniques

A press-moulded base can be a good start point for a coiled piece; you can coil straight on to the base while it is soft as the mould supports the form. Coils can also be added to leather hard slabbed pieces; care is needed managing the joins to avoid cracking. Where the clay will join, it is wise to soften the edge of the leather hard piece with water, and once joined, control the drying by wrapping with plastic to allow the moisture content to even out. If a crack does occur, catch it early and fill it with clay of a similar dryness or a paste made of dry clay mixed with vinegar.

COMBINING COILING AND PRESS-MOULDING

A press-moulded base can be a good start for a coiled form; score to ensure your first coil is secure.

Add slip, or slurry, and also score your coil to ensure a firm join. Blend the end of the coil to secure it to the press-moulded section.

Continue to add coils to build the form upwards, paying attention to the shape created.

Once the base has dried to leather hard and can support the coils, it can be removed from the mould.

Continue building to conclude the form; use ribs when the whole form is leather hard to create a smooth surface.

68 Chapter 5 – Slabbing and Press Moulding

CONTRIBUTORS

Slabs are a versatile building block for sculpture, whether used at the leather hard or press-moulded stage. The makers discuss how they have adapted this technique to arrive at the current point in their practice.

Patricia Volk:

I use clay straight from the bag, slice it with a wire, then I use a slab roller set at 1.5cm (0.75in) thick and roll about seven slabs at once. I stack them between sheets of plasterboard to keep them flat and to dry them evenly. Plasterboard is very cheap, you get it from a builders' merchant, and they can cut it into the size you need.

I was a trainee designer in a factory when I left school, which is where I learned pattern cutting: you have to be economic and make sure nothing is wasted. This is how I approach slab building; I make templates from lining paper and get as many shapes as possible cut from each slab. They are joined by scoring with slip; sometimes I roll soft slabs around a tube and then hand build on to them using coils. This is how I made the work for the ITV ident commission – I angled them to have some twist and after they were fired I worked out how to stack the separate pieces together; I like to try different arrangements. The best advice I would give for using slabs is make sure the clay is at the right stage before you use it; if it's too soft it won't hold its shape. I use a set square for my angles and to sledge the edges as the angles have to be right!'

Patricia Volk's studio: the slab roller was used to create a large, even slab and work is in progress around the studio.

Templates are made from lining paper; Patricia learned pattern-cutting skills as a trainee designer.

Chapter 5 – Slabbing and Press Moulding 69

Shapes are cut according to the template and are joined with scoring and slip; several works are constructed simultaneously.

The final parts of the assembly are joined and worked with ribs to achieve smooth surfaces and sharp angles.

Finished pieces are placed to one side and dried carefully before being loaded into the kiln for a bisque firing.

Following the bisque firing, the works are primed, painted with acrylics and sealed with varnish. *Opposites*, 2020, height 43cm (17in).

Cog, 2020, height 36cm (14in).

Paul Briggs:

My slab-built forms are for the most part more planned, measured and intentional. Early on, years ago, this work became the work through which I explore specific subject matter. Balance, the paradox of inside and outside, architectural structural references and materiality all serve as metaphors in this work. Ultimately, I am interested in the development of interiority on a continuum with exteriority. Equilibrium and balance appear where it seems none can be attained. My work primarily critiques traditions, broadly defined, where they impede the possibility of ongoing equanimity. I present equanimity as compositional balance. The most recent series of slab-built pieces are *Cell Persona: The Impact of Incarceration on Black Lives*, the *Black Pain* pieces, including the *Knotted (Refuted) Vessels*, and the present work, *Intuitive Responses to Black Poetry*. All of these pieces, in the words of Glenn Adamson, 'are remarkable for re-scripting the basic vocabulary of ceramics (slab construction and coils)'.

Paul Briggs, work from the *Cell Persona* series, 2019, height 20cm (8in).

Chapter 5 – Slabbing and Press Moulding 71

The process of press moulding to create multiple body parts is used by Wanying Liang – the forelegs of a horse feature in several of her sculptural works. A leg was modelled in clay, then cast with plaster to the halfway point to create the first mould. Once set, the other half of the leg could be cast to create a second mould. To make a full leg, clay was press moulded into both moulds, then joined at leather hard to create a full leg in the round.

Wanying Liang's studio; a long slab is rolled using guides to keep the thickness even.

The slab is pressed into a mould, the edges are scored and thick slip is piped on to the scored area.

Slabs that have been pressed into the partner mould for the other half of the leg are joined, completing the leg.

Once leather hard, the legs can be removed from the mould; the joining seam will be fettled and the edges of the hooves smoothed.

Several legs are press moulded to make the supporting base of a multi-part sculpture.

72 Chapter 5 – Slabbing and Press Moulding

Mark Draper describes his approach to the mould-making process:

> Depending upon the building I am working from, a plaster press mould has to be made for each elevation/façade. Some of my pieces need only one mould, others need many; up to forty I think is the most I have made for a project. I make press moulds because I usually want to make more than one model. Additionally, if I modelled the pieces as I went along and then joined them, I would have a problem keeping them all at the same level of moisture content, which can lead to splitting and warping as the piece dries. By making moulds, I can press out all the pieces in one session and let them get leather hard together so that I can join them in the same session.
>
> To make the clay master and mould for each elevation, I roll out several slabs of very fine clay, larger than the elevation. I have the photocopied drawing of each elevation pasted on to card. With a scalpel, I cut the deepest level out, usually the windows. I then place the card template (with the windows cut out) on to a fine pre-rolled slab, draw around the template on to the clay slab and cut out, for example, the windows and the overall shape of the elevation. I repeat this process, gradually cutting away the card template and moving forward/outwards with the different levels of detail/ornamentation, usually pilasters and pediments being the final lamination. I end up with a clay master composed of several layers, laminated with slip and with no undercutting, which is most important. The fact that the elevation is made up of layers is another reason why I produce a plaster press mould as the layers could separate during drying or in the kiln and could blow!
>
> Once I'm happy with the modelling, I place it on a sheet of glass, build a clay wall around it and pour in the liquid plaster. I leave it to set, remove the clay walls and original master; therefore, the original modelling is lost. I repeat this process for every elevation. Sometimes, I model from card. This works quite well when making the mould for the roofs. You need to seal the card with shellac to make it waterproof when pouring the plaster. I also brush washing-up liquid over the card which acts a releasing agent.
>
> When making domes, I cut cross-sections from card (the more the better), arrange them like fins on a card disc (using a hot glue gun), seal with shellac to waterproof and then fill in between the fins with wet clay to form the dome. As before, I pour plaster over to form the mould. When the mould is set, I can carve into it, which will produce raised detail, for example, the ribbed joints on lead roofs, raised lettering (you just have to remember that lettering has to be carved back to front as you are working in reverse). I leave all of the moulds to dry before I use them to make the piece.

Mark Draper's studio: Triangular Lodge work in progress, with elevation and roof press moulds.

Detail of elevation mould for the Triangular Lodge; note the numbers appear backwards.

Chapter 5 – Slabbing and Press Moulding

Freshly moulded roof section, a complex and sculptural form in itself.

Freshly moulded elevation showing all of the carefully modelled detail of the façade.

He describes using a press mould carefully:

> This is perhaps the most exciting stage of the making process. I brush and vacuum the press moulds to ensure that there are no plaster particles in the mould that might transfer on to the clay. I press the clay very firmly into the press moulds. If my thumb hurts when I'm doing this, I know I've usually got the clay in to the deepest recesses of the mould. I try to use my thumb to level off the back of the cast rather than employing a tool but usually I use a boxwood tool to make sure I'm keeping a clean edge. I then press a piece of clay on to the back of the cast and lift it out of the mould. Extreme care is needed here: if the cast drops back on to the mould, the fine detail can be damaged. You also have to be very careful not to distort the cast as you remove it from the mould.

> I press out all of the pieces from the moulds in one session to ensure evenness of drying. I constantly check the level of drying as I want the pieces to be leather hard so that they can hold their weight when I'm assembling the pieces. I always use fresh clay from the bag for the pressings. Scraps and used clay are re-wedged and used for modelling masters and mould making.

He describes the precision required for the construction process:

> All of the edges of the pieces/clay elevations are chamfered using a steel rule and scalpel and scored with a steel tool. I join the pieces with slip and reinforce the joint with a fine clay coil, smoothed into the corner. I'm looking for a very sharp, hard-edged finish so I never use a sponge,

Mark Draper, ceramic model based on Sir Thomas Tresham's Triangular Lodge, 2015, height 28cm (11in).

which can soften the corners, edges and details. Once the piece is assembled, I tidy and sharpen up the corners and the edges with boxwood modelling tools and a scalpel. I usually work in four hourly sessions, and usually manage to get the piece assembled in one session. If not, I store the piece and any unjoined pieces in the same plastic bag. I have a collection of the softer, thinner bags that used to be distributed at supermarkets before we paid for them. The plastic used now is harder and can damage the detail where the bag touches the piece. I try to achieve in my pieces the look of an 'architect's model' rather than a 'model village' style. I never model on foliage, animals, pathways, etc. I strive to achieve a pared-back look that shows the architecture in its pure form.

Chapter 5 – Slabbing and Press Moulding 75

CHAPTER 6

SCULPTING AND ADDITIONAL TECHNIQUES

Search for definitions of 'sculpting' and you will find an array of verbs, ranging from general terms like forming, making or shaping to specific technical terms, such as casting, carving and modelling. Much of sculptural work in clay is formed by the hand or tool, often combined with the techniques already discussed, which broadens the options for problem solving and realizing more ambitious work. Sculptural work can be further defined as abstract, figurative or representational; depending on whether or not it is an accurate representation of a person, plant, animal or building, for example, or if it relies on the artist's interpretation, displaying a less obvious connection to the source material.

This chapter discusses practical methods to help support your creative intention, as well as supplementary techniques to the main construction methods. This includes using sprigs, which are small, moulded shapes fixed to the clay surface, and making handles for functional use. The contributors discuss their individual approaches to problem solving and combining techniques to create impressive sculptural works.

PLANNING THE FORM

Many makers work from drawings or photographs, and sometimes from life; having reference material within easy reach or displayed nearby can help to keep the overall form in mind during the build phase. As well as keeping the shape on track through regular reference, small details can be accessed easily;

◀ Claire Partington, Ceramic artworks from the *Taking Tea* installation for Seattle Art Museum, 2018.

some makers keep a laptop handy, others pin pictures on the wall or have a sketchbook open on the workbench.

Sculptural works can be approached using a variety of methods, which can include making repeat components using a press mould, coiling, using soft or hard slabs, or modelling as a whole and hollowing out. Planning the building technique and carefully choosing the type of clay will help encourage a successful outcome. Support can be an issue for standing figures or upright forms and the choice of clay can help aid stability. Soft clay is heavy as it contains a lot of water and forms can sag, bend or even collapse at this stage. Many makers advocate the use of fibre or grog to add strength to the clay for the build phase – the easiest option is to buy ready-made paperclay or grogged bodies from a supplier. You can mix grog or paper pulp into clay yourself – a little research is recommended when taking this route.

Forms should always be hollow once constructed; an important part of planning is considering the air flow for drying and firing. If there is a cavity and no hole to allow air to escape, there will be an explosion during the firing. This happens when steam is created as the temperature rises, then cannot escape. Building in holes and space as you go is one approach; removing clay and making holes later in the build is another.

Weight and balance are other important factors when planning and can influence decisions about composition; for example, it is more straightforward to make a seated figure stable than a standing one. Anchoring a potentially precarious sculpture to a clay base or plinth and firing the ensemble as a whole can be a helpful stabilizing mechanism. When looking at contemporary works and exhibits in museums, this is a frequently used solution; bases can range from the very simple to highly decorative, adding presence and a little context to

Wanying Liang's studio: work in progress – using slab-built supporting structures inside a coil-built piece.

The perforated section of this sculptural work offers not only visual interest, but enhances air flow to assist drying and lightens the weight of the structure.

the work. A classic example of this type of problem solving is the 'Staffordshire Flatback', produced in England from the seventeenth century onwards, where figurative compositions designed to be displayed on a shelf or mantelpiece were safely adhered to a structure with a flat back and base.

Making the base a little thicker will add weight and aid stability. When approaching upright human and standing animal figures be aware that the centre of gravity may not be at the base, so there is potential for works to move or warp in the kiln, even if the build is successful. There are several ways that works can be supported during making and firing; a few are discussed here, but you may discover your own bespoke solution tailored to your particular work.

SELF-SUPPORTING CONSTRUCTION TECHNIQUES

Support comes in three ways: self-supporting, internal support and external. Making work which is self-supporting throughout the building process can be achieved using a number of methods, one of the simplest being to join two pinched pots to create a hollow form. This basic structure can be pinched, pushed and embellished to achieve the desired shape, and joined to other hollow forms to create a larger piece. Another type of hollow form is a cylinder, which can be made by wrapping a soft slab around a support such as a cardboard tube; depending upon the type of clay and size required, some soft slabs can support themselves. As soft slabs are malleable and can be moulded and shaped into a number of ways, support can be provided on the inside or underneath using scrunched-up newspaper. The advantage of using newspaper to fill a cavity is it need not be removed pre-firing; it will simply burn away in the kiln. Another straightforward, self-supporting way of building incrementally is to coil; in sculptural works, as with making pots, there is the chance to check the shape carefully as you build, and as the first coils dry and stiffen they provide support for the next section.

Some makers complete a work as one solid piece and hollow it out before fine detail is added. Depending upon size, this can be done by cutting the work in two, hollowing out both sides and slipping and scoring them back together. For a larger piece, for example, arms, legs, torso and head may be cut off and hollowed separately before being joined back together before firing. Keeping the walls a consistent thickness is important; a looped tool is useful for hollowing out. When putting a form back together some internal support may be required; this could be achieved by using scrunched-up newspaper or struts made from leather hard clay, placed inside to offer an internal framework, like rafters in a roof. Some makers cut up larger works and disassemble before firing, putting each section in the kiln separately. This means sizeable works can be made in a smaller kiln; for this type of work there is a substantial post-firing process which involves assembly, glueing, filling and painting.

SCULPTING A HEAD FROM PINCHED FORMS

Using two equal-sized balls of clay, make two identical pinch pots, to be joined at the rim.

Score the rim of each pot and add slip to secure them together: join firmly and wipe away any excess slip.

Blend the join with a tool and smooth the surface to complete an egg-shaped form. Make a small hole in the base to allow air to escape when firing.

Map out the features; it can be useful to refer to a drawing or image. Push into the clay for hollows and add clay to build up areas such as the brow and nose.

Continue to further define the features by adding and subtracting clay, and using tools to sculpt finer detail.

Once the features are complete, different textures can be achieved using a paintbrush, fingertips, or a sculpting tool; experiment to see which suits the work best.

This work was finished with a layer of white slip, bisque fired and then clear glazed.

80 Chapter 6 – Sculpting and Additional Techniques

EXTERNAL SUPPORT

This can be provided by a structure that is removed once the work has dried enough to support itself or if combustible, it can be left *in situ* to burn out in the kiln. Anything can be used to prop up parts of a form in the early stages. Clay shrinks as it dries so if your support is a dry sponge, for example, it can move a little to accommodate the shrinkage. If your support is a brick or piece of fired clay, it cannot move and breaks could happen in the work as the clay shrinks and becomes more fragile as it dries. Monitor work during the drying stage to check on props and make adjustments as necessary.

Adjustable armature stands can be used to offer external support during the making phase – they are a weighted vertical rod with one or two adjustable horizontal rods – you can move them to provide support where it is needed but removal before firing is necessary. Wooden rods, sticks or skewers also offer support in this way and can be discarded once the work has dried a little and can support itself, or wood can be left to burn away in the kiln. Supports made from the same clay can be fired in situ as long as you are careful that it is not joined in any way, so it can easily be removed after the firing. This is often how animals such as horses are made, with the support placed under the stomach to take the weight when the legs are not yet able to. Be aware, if using kiln props or nichrome wire (wire that can be fired in the kiln) to support a structure, that they will not shrink like clay in the firing; this can cause cracks where the stress between the structure and the clay is unworkable.

Some makers build, dry and fire figures lying flat; for example, a piece might start out on their back or side, but will be displayed upright post-firing. A slice of upholstery sponge can be a good support for delicate works that are lying down during making and drying. Support during firing can be offered using ceramic fibre sheets or a purpose-built 'shrink slab' from the same type of clay, which is a cheaper and more bespoke option. A shrink slab is a structure made from leather hard slabs perforated with holes, which uses less clay and allows good air flow. It supports delicate work during the firing and is made from the same clay, so shrinks at the same rate. It need not be neat and tidy as it will be discarded; there are plenty of examples online of makers adapting a shrink slab to support a specific piece of work. Works can move during firing due to expansion and shrinkage and this can adversely affect pieces with large areas contacting the kiln shelf; sometimes a layer of sand or alumina powder underneath the work is helpful to aid movement.

Once issues surrounding composition and support have been resolved, the best approach is to build the rough shape and gradually refine the details a stage at a time. Clay can be added or subtracted, pinched, pulled and manipulated; this is the fun, creative part and can also be the most time-consuming. Makers all have their favourite tools, but many primarily use their fingers, then wooden tools and finally, metal sculpting tools to hone definition as the detail increases.

Patricia Volk's' studio – these pieces are made by combining slabbing with coiling: supports are put into place while the clay dries to prevent sagging or distorting.

SPRIGS AND ADDITIONS

Intricate detail can be sculpted, carved and also added as sprigs, which are traditionally low-relief shapes made in a small plaster mould and applied to the work at the leather hard stage. The classic example would be the white additions on a blue Wedgwood Jasperware piece. Making a plaster sprig mould is quite straightforward: first, source a small object to cast, for example, a small scallop shell, fossil, button or brooch, or make your own object out of clay. Choose something simple that has no undercuts so that it can be released easily from the mould; be aware that any holes will get filled with plaster, so plug them with clay first.

Place your object on a surface that will release easily from the plaster, such as a sheet of glass or a rolled-out slab of clay. Build a clay wall around your object, leaving a gap of about a centimetre, or half an inch, between the object and the wall. Blend the wall joins, ensuring there are no gaps from which the liquid plaster can escape. Paint gently all around the surface with soft soap, which is made for working with plaster. If you don't have access to soft soap, liquid household soap will suffice as a barrier to ensure it will release. Wearing a respirator, which is essential when working with loose plaster powder, mix up a little plaster according to the manufacturer's instructions and pour. When you have poured the moulds, leave them until the plaster has firmly set before dismantling. Discard any clay you have used in this process as it will be contaminated with plaster and could explode in the kiln.

Sprig moulds are commonly made from plaster, but you can also make them from bisque-fired clay, as long as the clay used is fine enough to retain a good level of detail. A bisque mould is very simple to make – you can simply press a found object, such as a shell, into the clay to leave an impression. When dry, fire to bisque temperature (1000°C or 1832°F). This means it will still be porous, so will remove moisture from wet clay pressed into it, in the same way as a plaster mould. Little moulds used in food preparation for fondant icing may work for sprigging, depending upon what they are made from; clay sticks to plastic so it is not ideal. If it is silicone sometimes a little talc is required before putting the clay in the mould, to ensure it will release easily.

The process of press moulding, then coiling this pot was shown in the previous chapter. By adding a snip and handle, it has been made into a jug, and sprigs have added decorative interest.

The sprigs were made in a clay mould: shells were pushed into a thick slab of soft clay, which was fired once to bisque.

82 Chapter 6 – Sculpting and Additional Techniques

Mark Draper's studio: a small plaster sprig mould has been made for repeat details on a building façade.

Clay is pushed into the mould firmly; any excess is scraped away with a wooden tool and the sprig is released using a small blob of clay.

Wanying Liang's studio: work in progress. Several handcrafted additions have been secured to the main form to create beautiful relief decoration inspired by nature.

Once you have a mould, be it plaster or bisque, fill it with just enough clay and press firmly; if you overfill it a little you can scrape away the excess with a plastic or wooden rib (a metal one can catch and damage plaster). To release the sprig from the mould, form a little ball of clay and press it on to the sprig, pull away gently and it should bring the sprig with it. If the edges of the sprig are uneven it can be gently tidied up with a damp brush or sponge. Try not to overwork it or detail can be lost. It can be worthwhile producing several sprigs in one session and keeping them wrapped in plastic in an airtight tub until needed. Applying sprigs to the main body of the piece is achieved by scoring and fixing with joining slip.

Aside from sprigs made in moulds, many makers add multiple handmade additions to a form, often completely covering the structure to create surface interest, each addition secured by scoring and using slip. Another way to apply decoration to a surface is to pipe very soft clay using a piping bag, which a chef would use for icing a cake. Several makers feature this technique in their work – getting the clay to the right consistency is crucial and there is a recipe, courtesy of Wanying Liang, in the additional material section for making a paste.

Chapter 6 – Sculpting and Additional Techniques 83

HANDLES AND FUNCTIONAL ADDITIONS

For functional objects to work well there are additions, such as handles, snips, spouts and feet, which need consideration in terms of ease of use (known as 'ergonomics') and visually as a means of adding character to a piece. A good hand-built handle can feel more comfortable than a manufactured one, as it was made by the hand, for the hand. There are numerous ways to make handles – there is no right or wrong, and you will find what works best for you. A simple handle can be made by rolling a coil, trimming the ends and fashioning it into a curve, before leaving it to dry to leather hard. You can add detail by pushing stamps into the surface or making marks with a tool or your fingers. You can change the shape by using hands or tools to squash and form the clay. Another way to make a simple handle is by rolling a thick slab and cutting a side-view profile shape with a sharp knife. Again, leave it until it is leather hard before joining; when it has stiffened a little, you can smooth angular edges and add details to alter the design.

Pulled handles are often used with thrown mugs or jugs and are equally suitable for hand-built ones. While the technique can be a little tricky to get the hang of, once you are proficient it is a very quick way of making multiple handles, with the option to vary the size as required. Take a bowl or jug of water and work over it, so it will catch the drips as you pull the wet clay. Take a large, thick coil of clay and hold it firmly at the end, using your weaker hand (left if you're right-handed, and vice versa) and let it hang vertically. Dip your stronger hand into the water; close your index finger to your thumb around the

PULLING HANDLES

Hold a large coil over a pot of water; make a loop by putting the tip of your thumb against the tip of your forefinger. Wet the loop and pull down the length of clay.

Repeat this action, wetting your fingers each time so that the loop easily slides across the clay. The clay gradually becomes smooth and even; when it is ready, fashion it into a curve on a board.

coil at the top. Pull your hand downwards gently over the clay with a minimal amount of pressure – it should slip smoothly through your fingers because of the water. Repeat this action, dipping your fingers in the water each time. Some might liken this action to milking a cow!

The coil should gradually take the shape made by the loop between your thumb and index finger, becoming more even and getting longer and thinner as you work it. If you get a straggly bit or a section gets too thin or breaks off, put it to one side to reclaim later. Once you have a nice, even length of clay the right size for your handle, snip it off with your fingers and fashion it into a curved shape before placing on a board to let it dry to leather hard. Once it has dried enough to work, you can trim it and join it to your mug or jug. There are several variations of this method and there is much online footage available.

Another way of getting an even handle is to use the wire from a bag of clay. Take the wire and fashion a loop, twisting the additional wire to make a straight 'stalk'. Use a brick-sized lump of clay on the workbench; it helps if the clay is quite soft. At the end of the section of clay, push the loop into the side, just below the top surface, with the 'stalk' pointing upwards. Push and pull the wire to drag the loop through the clay from one end to the other. You may need to peel back clay at the top to reveal the section pulled through, which should be even and ready to form into a handle shape. Some makers find this method difficult; others love it – always use a way of working that suits you best.

To make multiples of the exact same handle, cast a press mould from an original one you have taken the time to make, or from an existing object. Moulds can be made as described for sprigs. For those with access to an extruder you can extrude

Trim away excess clay, leaving yourself a little more than you need, as you will trim again when you fit it to the pot. It can be useful to make a spare handle in case of any issues when trimming or joining.

Leave to dry to leather hard, when the handle will be ready to attach; you can fettle any blemishes with a damp sponge at this stage.

JOINING A HANDLE

Once leather hard, the handle can be trimmed to fit flush to the pot. Score both points where it will be joined.

Add slip to these points and gently place the handle against the pot to leave two small blobs of slip.

Score these points on the pot; this scoring tool was purchased from a supplier, but you could also use a pin or craft knife to score.

Add some fresh slip and firmly push the handle to the pot, with one hand supporting inside the pot to minimize distortion.

Clean around the join with a tool or damp brush for a neat finish. Check for small cracks during the drying phase and fill if necessary.

86 Chapter 6 – Sculpting and Additional Techniques

multiple handles in one session – if you make a large amount you might want to keep some for another day by wrapping them in plastic and storing them in a lidded plastic box to keep them damp. Some useful advice when making handles is always to make a spare, then if one breaks or anything goes wrong at the joining stage you can simply reach for another.

When adding handles, join them using an ample surface area, sometimes achieved by trimming the handle at an angle; the join needs to be able to hold securely when your mug or jug is full of liquid and quite heavy. To join, trim the top and bottom edges of the handle so it fits flush to the wall of the pot. Score both ends of the handle where it will join and dab a little joining slip, or slurry, on to the scored area. Hold it lightly on to the pot wall so the slip leaves two little blobs where you will need to score. Score those areas and add a little more slip, then press the handle and pot together; sometimes a little slip will squelch out in the process which can be neatly cleaned away with a damp brush. If your pot is a little soft or the walls are thin, support the wall from the inside with your hand as you press the handle against it – this will prevent it breaking or distorting with the pressure of joining.

SNIPS, SPOUTS AND FEET

Making pouring snips and spouts for jugs and tea pots is fairly straightforward; just ensure the edge is not too thin, which would make it vulnerable to damage with regular use. Making a simple snip is best performed when the clay is fairly soft; you may need to wet the area of the rim where you wish it to pour from. Stick out your middle and index fingers of your weaker hand, tucking the other fingers towards the palm (making a V sign) and place your fingertips upside down on the outside of the pot. Dip the index finger of your stronger hand in some water and stroke it up the inside of the pot between the two fingers on the outside. You may want to repeat this a couple of times or it might work well first time. Don't try and fettle it once you're done as it will be soggy; wait until it has dried a little before using a damp sponge or fingertip to smooth out any bits of slurry or finger marks.

A simple pouring spout can be made from a small slab, which has been cut and shaped; a teapot spout can be made from a slab that has been cut, rolled around and joined. Always dry to leather hard before joining to the main body of the pot to minimize distortion.

Adding feet can be used to elevate a pot to add character or for functional use, as with a cutlery drainer or colander. Feet can made very simply by forming clay into little balls that are joined on to the base or you could make them from more sophisticated shapes; it is a nice detail and works particularly well with plant pots. An alternative way to elevate a pot is to add a foot ring, which is made by rolling a long strip, which is curled into a circle and joined to the base.

TROUBLESHOOTING: DRYING, CRACKS AND REPAIRS

It is worth knowing a few basic ways to rectify common issues such as cracking and how to repair accident breaks if a piece has been knocked. Prevention is best and a good way to avoid serious cracks is to control the drying of your work, as it can be very sensitive to draughts, strong sunlight or indoor heating. These factors can make drying uneven and cause stress where the clay has shrunk at a different rate. Control your drying atmosphere by adding a protective layer – a newspaper tent or layer of thin plastic with holes punched throughout will slow the drying process and make it more even. The thin plastic used for covering dry-cleaned items is brilliant, and also useful for wrapping work to keep it damp between making sessions.

Check your work regularly during the drying phase to spot cracks before they become serious. If a small crack appears, you can often scrape a little clay from near the split with a metal sculpting tool and push it into the gap, filling and compressing the new clay into it and smoothing out the mend without using water. This can be effective as the filling clay is at exactly the same stage of dryness of the clay around the crack; therefore, they should continue to shrink at the same rate. Another method is to use vinegar to make a thick slip by adding it to bone dry clay and creating a paste to use as filler. If it is the same colour as your piece, paperclay is another filler option. If the crack appears after the bisque firing, again use paperclay as filler at this stage; there are also commercial products, such as Mend a Friend or Bisque Fix, which can be used at this point. If a crack appears in the final firing, your best option is to consider if it really is detrimental to the piece, and this depends on where it is located. You can discreetly fill it with conservation materials or products, such as Milliput, which comes in several colours. Another option is to highlight it decoratively using a gold filler or Kintsugi kit.

EXPERIMENTING

There are several techniques that can be pushed further or combined to allow for more possibilities. Extrusion can be used for making coils or handles, but it can also be used sculpturally to make lengths that can be manipulated into shapes and joined to form a structure or added to a work made using another method. Whatever methods are combined, clay pieces are best joined when all are at the same stage, for example, when all pieces are soft or all pieces are leather hard, so that they can dry and shrink at the same rate.

It is well worth experimenting if you have an idea about manipulating or constructing clay that is a little unorthodox as this is how discoveries are made. It is worth remembering that most experiments can be reclaimed before firing if they don't work out. Anything is worth a try; in fact, the only thing you

Extrusion: an extruder is a metal tube into which clay is loaded. By pulling a handle, clay is forced through a 'die' – these are examples of dies of different shapes and the holder into which they fit.

Clay is forced through the extruder, creating a length that takes the shape of the die that is fitted.

Extruded lengths can be immediately cut, twisted or altered as the clay is still soft. Once leather hard, they can be used for building or adding to forms.

This is an example of a sculptural form created by assembling and joining leather hard extruded lengths. Extrusion can be combined with other methods.

88 Chapter 6 – Sculpting and Additional Techniques

must never do is fire clay with plaster in it as it will explode in the kiln. Working with clay is great for problem-solving skills and resilience, and those in the ceramics community are generally very generous in sharing their discoveries and encouraging others to keep pushing.

CONTRIBUTORS

It is so interesting to see how the makers contributing to this book have adapted a variety of techniques over the years; most have arrived at this point in their practice by experimenting and taking risks. Clay choice is crucial and it is useful to understand how a specific clay best supports its purpose.

Claire Partington discusses her approach to creating her intricate, sophisticated figures:

> My approach is experimental and not based on formal taught ceramic techniques – I studied sculpture for my first degree. I use quite a range of clays; white grogged earthenware with molochite is a good white base. I also use a grogged red terracotta, paper porcelain and T material for larger works, especially for people with legs. The figures that have dresses are really just bottle or vase shapes. I start with a slab rolled out for the base and cut it to a profile of the shape I want the dress to be and coil-build up and in and up, effectively like a hip flask for the wide pannier dresses. I make the arms separately on a dowel or wooden spoon, so I will coil the arm shape then join it. It takes about four months to make one; they're quite large and you have to wait for the clay to dry and become hard enough to support the weight.

Claire Partington's studio: work in progress. This figure is made from a rich red clay, coiled and modelled with added sprigs. The work in progress is wrapped in plastic and inspirational material is pinned to the studio wall.

Detail of the same piece fired, depicting the beautiful red colour of the unglazed clay, and the texture and intricacies of the modelled and sprigged decoration. The contrasting circle is first slipped and glazed, with transfers added.

Creating a base or pedestal for a figure: a slabbed base has walls added, and internal struts are prepared to the same thickness.

The struts create a grid structure and holes are punctured throughout to aid drying and create air flow, and to allow steam to escape during the firing.

The dresses support themselves, but figures with spindly legs have a box-slabbed base. These contain a support grid of upright slabs as supports inside, with holes in so the air can flow, then I put a lid on, so I have a sealed box as a plinth. I start coil-building spindly legs going up; I'll start with the position where the feet are and I will stand in the pose I think the figure should adopt: rather than working from a picture, I use myself. I think about how I am standing, with my hand on my hip, looking at the position of my feet and thinking where is my weight going?

I use dowels in the slab that I'm coiling around for the legs, which will be removed. If the figure needs extra support, I might have a dog – I'm interested in the relationship between people and animals; the dog is part of how that person wants to present themselves and their status. Like choosing shoes and a bag to complete a look, it goes back to the language of portraits; the objects people are most proud of appear in both classical portraiture and selfies today.

Using lots of sprigging is a really nice way of adding more to the story, a means of including more of the information I want to convey. I cast my own sprig moulds from fine casting plaster; I will select objects relevant to the story. I collect tiny toys and jewellery; you can find anything these days on eBay. I made an Elizabethan boy about town and found an amulet just the right size on eBay. I cast found objects or if it's something specific, I can make a wax model and get it cast in metal. I used piping to decorate a dress for the Seattle Art Museum show; I wanted it to be like fancy confection, overly decorated and over the top. She has a base made from MDF with gold leaf, so she's over the top and then raised on a golden pedestal.

I'm not trying to achieve some amazing perfection; if it's cracked and I've spent four months making it, that's part of the work. I don't have a problem using conservation materials to deal with a crack. They're quite robust and not dainty little pieces. My advice would be to do what you enjoy and be inventive, do what works for you.

Starting with the pedestal, the figure is modelled from the ground upwards; a decorative barrel, and later a pug, are added both for support and to expand the narrative. The finished figure is shown at the beginning of this chapter.

Claire in her studio, working on sprigged details while sculptures pause for drying time at different stages in the making process – note the legs with wooden supports in the background.

A close-up detail of the plaster sprig moulds that Claire has cast herself, which can be used to create a variety of decorative additions. The recumbent figure will be finished in a white glaze and the comb will be lustred gold.

Chapter 6 – Sculpting and Additional Techniques 91

Dirk Staschke's studio: work in progress. Using a wooden frame for support during the building stage, a clay frame is created within and a supporting structure for the bird is built.

The bird is modelled on to the supporting structure and joined to the frame at the head and tail to secure it in place.

A view from a different angle showing the detail present in the head, all modelled by hand. Further objects will be added to build it into a three-dimensional still life.

The modelling of part of the still life is complete; a frame press moulded in sections will be added to finish the piece before it is dried slowly and carefully prior to firing.

The finished work, front elevation *Translation #1*, 2014, height 71cm (28in).

A specific clay body used by Dirk Staschke is 'Three Finger Jack', which comes in both red and white; it contains added grog and is available locally in Portland, Oregon, where he is based:

> I use three different clay bodies: stoneware, earthenware, porcelain, and I use porcelain slips coloured with mason stains. Most of the objects in my sculptures are hand-built, but if I need multiple repeats of a specific object it is best to make a plaster mould. If I need a vase in a sculpture, I will throw it on the potter's wheel. The profiles for the ceramic frames are built by hand and then cast in plaster. All of the decorative work is then added to the frame.

From his extensive experience, he offers these insights: 'If an object is long and thin, add nylon fibre to the wet clay. This increases the tensile strength of bone dry clay. Dry slowly: I have taken up to eight weeks to dry larger pieces.' Drying takes place in a home-made plastic tent to allow the work to shrink gently in an evenly controlled atmosphere.

Chapter 6 – Sculpting and Additional Techniques

Experimenting with different ways of making additions has helped the author develop her own style:

> I use several hand-building techniques that I have adapted over the years, including the use of a bisque former to create decorative additions. This is a flat sheet of clay elevated by attaching a ring of clay around the edge underneath, and the whole construction is fired once to bisque temperature of 1000°C, or 1832°F. This means the former is porous, and although saturated more easily than plaster, has some advantages for the purpose I use it for.

Jo Taylor's studio: using a bisque former. The former is made from a slab of clay with a coil fixed underneath to elevate it: after being bisque fired, it is still porous. Using small pieces of clay, a motif is built on to the former.

Dipping the fingers in water then firmly pulling along the clay motif adds movement and directional marks. Multiples can be made at the same time filling the surface of the former.

Any rough bits can be smoothed over with a wet paintbrush, then, after around ten to fifteen minutes (depending on size), the motifs can be carefully removed using a thin metal kidney.

Sometimes a twist is made to the motif before placing it on a wooden board, to add extra movement and direction. The motifs dry out to leather hard before being touched again.

Once leather hard, the motifs can be fettled by using a damp sponge (or diddler) to smooth out any rough edges. Once complete, they can be wrapped in plastic and stored ready for use.

Jo Taylor, *Vari Capitelli ii*, 2019, height 44cm (17in). This work was coiled and thrown, with extruded and handmade additions using a bisque former.

I make small coils of clay and arrange them into shapes on the bisque former. Using water, I smear and work the clay with my fingers to add a sense of movement to the pieces and gently take away any slurry with a damp brush. I trim around them with a craft knife and leave them for around ten minutes, depending upon the temperature and how dry the former is. As it is so porous, it absorbs the water from the clay much quicker than plaster would, and when I come to gently ease them off with a thin metal kidney, there is no chance of chipping any plaster into the clay. Another adaptation I use occasionally is to extrude lengths and alter them to create decorative additions. I cut, bend, pull and form the ends so that they twist and turn into flourishes, which are then left to dry to leather hard before attaching.

In terms of combining techniques, I create larger vessels by first coiling, then putting the pot on the wheel to throw the coiled section to both make it even and increase the height. I let it dry a little before coiling another section and again throwing that section on the wheel. I continue in this way, which allows me to make a large form incrementally. I am limited by the measurements of my kiln, so I know the maximum height of work I can make will be 50cm (before firing) – I have it marked on a tape measure to keep a close eye on heights as work evolves. I know that Earthstone ES5 fired to stoneware will shrink around 6cm from the maximum height 50cm, making shrinkage approximately 12 per cent. I factor this into the making and it is important when making a series that need to be of similar heights.

Eusebio Sanchez also finds kiln size an influencing factor:

If I could, I would make large works all the time – I like the presence and challenge it gives: when it's finished it's more like a statement of what I want to say. I have access to the university kilns which are 1m high – I can make one large piece from two parts that can be assembled post-firing, which also makes it easier to transport.

Eusebio Sanchez, *A Convoluted Journey*, 2019, height 155cm (61in).

Wanying Liang's studio: works in progress constructed from various methods, drying in preparation for firing.

Chapter 6 – Sculpting and Additional Techniques

Mixing techniques as a means of problem solving is often employed by makers, including Wanying Liang:

> My works are normally made using multiple methods. The most common one is coil building. It is the most flexible and unlimited making method for me. You can almost use coil building to make any shape you want. Slab building and mould making are used when necessary; they are very efficient and can save me a lot of time. One big challenge is to attach parts made using different methods. It is difficult to keep them at the same humidity because their drying speed could be very different. I like stoneware clay and usually add paper pulp if I can mix clay by myself. The paper pulp helps to strengthen the clay (you will find it essential when you want to make a relatively big piece). I use commercial clay, too, for convenience. It needs more patience and caution when drying the works (it requires twice the time at least to dry compared to the clay I mixed by myself).
>
> One thing I learned at Alfred University is to use drywall to help with loading ceramic sculptures – it is usually used in building a house. It can be risky to move delicate ceramic sculptures before they are fired and this can lower the risk during loading, with a front-loading kiln. If you make a large and heavy piece, put two pieces of drywall under your sculpture before you start building and add some sand between the two pieces. After finishing your work, you can slightly push your work with the top layer of drywall into the kiln (it is easier to do it with a pump cart). The sand helps in reducing the friction between the two layers. Your piece can be fired with the drywall; it keeps supporting the work until fired to a high temperature. Also, don't forget to put a piece of newspaper under your work before you start in case your clay sticks with the drywall or it may cause cracking in the drying process.

Work in progress, constructed from different elements joined at leather hard, with pinched additions.

Lynda Draper, *Portrait*, 2020, height 80cm (31.5in).

Unfortunately, there is no equivalent of this material in the UK building industry, as similar sheets contain plaster, which cannot be fired in a kiln. An alternative approach for large or delicate sculptures is to build the work on a kiln shelf before putting into a front-loading kiln, which is one of the processes used by Lynda Draper: 'I am pretty dependent on utilizing a hairdryer; even then I must be careful not to rush the works too much, to wait for sections to firm up before proceeding, so I find it best to build a couple of works at a time. Often, I build complex works on perforated kiln shelves that can be placed directly into the kiln.'

CHAPTER 7

SURFACE TREATMENT PRE-FIRING

Decorating a surface by adding texture and colour, or by working with coloured clay, are ways in which a form can be resolved before it reaches the kiln. If all of the work is done before the first firing, the glazing and second firing can be very straightforward, or perhaps one firing may suffice. This chapter examines ways of creating texture and colour at the raw stage, with a focus on using slip; this liquid, coloured clay is incredibly versatile in its use for decorative finishes.

TEXTURE AND SURFACE

Pattern and texture can be added to clay at both the soft and leather hard stages. When soft, clay is very responsive and its surface can take on the texture of a variety of objects; many interesting ones can be found around the home, such as an offcut of textured wallpaper or a patterned piece of fabric, such as a crochet coaster or piece of lace. A clay slab can be rolled on to a textured sheet and will take an imprint of the pattern – experimenting to see what works best will yield interesting results. Rolling leaves such as ferns on to slabs will produce satisfying imprints – leaves with pronounced veins work best; for example, fir and Leylandii give great texture. Ingredients from the food cupboard can offer more abstract surface marks – sprinkling rice, some lentils or seeds on to a slab, then rolling over them gently will leave scattered indentations. They can be removed before going into the kiln, but it is easier to leave organic matter to burn out during the firing.

Ready-made stamps and rollers, normally made from carved wood, can be used to make impressed patterns and can be purchased through pottery suppliers and online. The patterns are often themed and include various animals, plants and paisley patterns. Creating your own stamps and rollers can be achieved by making them from clay and firing them once to a bisque temperature of 1000°C (1830°F). They will be

A crochet doily is placed on to a slab of porcelain and rolled across with a rolling pin.

Peeling away the doily reveals the texture that has been impressed; the slab was used to make a press-moulded plate.

Blue slip was painted on at leather hard and sponged away to leave it in the recesses before firing and clear glazing.

◀ Madoda Fani, *Ibhokhwe* (The Black Goat), 2019 height 66cm (26in).

Fir leaves can be used to add texture.

Place on a slab and roll across with a rolling pin.

Wooden stamps work best when pushed into soft clay.

Surface patterns can be created using different stamps.

Wooden rollers can be used to create repeat patterns.

Jo Taylor's studio: modelled clay additions can be added to a form to create surface interest.

Once the position has been decided, the addition can be joined by scoring with slip.

Building up the additions can change the energy and appearance of the underlying form.

Jo Taylor, *Vari Capitelli viii*, 2020, height 41cm (16in).

100 Chapter 7 – Surface Treatment Pre-firing

Wanying Liang's studio: work in progress. These sculptural components illustrate how perforating a form can add surface interest and how using additions can change the appearance of the underlying form.

This sculptural component combines a surface perforated with numerous holes and a carved area at the base. The contrast in surface and scale of marks completes the decorative interest so that when it is glazed simply in white the viewer can read this intriguing form.

porous, so will not stick to the soft clay when used. Soft clay is so responsive that any mark you make will leave an impression, so experimenting will help work out what suits your work best. Look out for pebbles, tools, kitchen items, anything that can create an interesting mark and just re-wedge the clay each time you try something new until you are happy with the surface created – it's exciting to discover something that works well through trial and error.

Fixing multiple clay pieces to a structure at leather hard can completely change the surface and appearance of your work. Sprigs and piping were discussed in the previous chapter as additive ways of creating surface interest; any modelled detail can be added by scoring and glueing with joining slip, or slurry. As well as adding to the surface, many makers take clay away as a decorative option; one method is piercing, which is best performed at the leather hard stage. A hole cutter or craft knife can be used to cut holes through the surface; this technique is often used for making tea light holders, colanders and cutlery drainers.

A satisfying process is to carve into the surface to create relief; this can be sophisticated depending upon the skills developed and can be dramatic if the clay structure is quite thick, allowing for deep tracts to be removed. It works best if the clay is just at the right point of leather hard – the only way to judge this is by trial and error, but you will feel when it is right. The same goes for choice of tool: a sharp metal sculptor's tool or craft knife will work well, or you could try a hole cutter or small looped tool – everyone has their own preference

Carving is best performed at the leather hard stage with a sharp tool.

Combining different depths will create a range of shadows; carving can be freehand or may follow a pattern traced on the surface with a pencil.

Glazes can enhance a varied surface or carved works can work equally well unglazed.

Chapter 7 – Surface Treatment Pre-firing **101**

Madoda Fani's studio: using a sharp tool a regular pattern, which has been sketched out lightly, is carved into the surface.

Having carved out a repeated pattern, the form is incised further using a sharper tool to create additional texture.

Madoda Fani *Untitled I* (carved), 2019, height 50cm (20in).

depending upon the type of marks required. Patterns can be sketched on to the surface in pencil first to guide where to carve, or some makers work in a free-hand way, which is more spontaneous.

COLOURING CLAY

Many clays have a beautiful natural colour and surface texture if left unglazed, which can be an important consideration at the point of purchase. Mixing stains and oxides into the clay before making is a way of adding colour without the need to use slip or glaze, except a clear glaze if required. Commercial glaze and body stains, and oxides can be added to any clay, although the whiter the clay is, the clearer the colour will be. Adding colour to porcelain in particular gives a clean and clear colour. Proportions can vary and some testing is worthwhile to obtain the right shade and intensity; oxides can be much more powerful per weight than commercially produced stains. If the work is being made for tableware, check with the manufacturer or supplier that the oxide is food safe.

There are several ways in which makers approach the colouring of clay – some mix it up as a wet paste to be dried on a plaster bat before they wedge it and seal it in a plastic bag. If you don't mind wedging, another way is to mix colour as a paste directly into clay, which is quicker as you don't have to wait for it to dry and you can use it immediately. As soon as you work with ceramic powders, you will need to wear a respirator mask; protective gloves to protect your hands are recommended for the manual mixing. Clear plastic safety glasses are also worth considering, as over-enthusiasm in the initial mixing stage can cause the water and powder mix to squirt.

First, weigh out your balls of clay – for consistent colour, accurate measuring is essential. An example would be for every 500g (1lb) ball of clay, add four flat teaspoons of stain. Make a generous indent into each ball and add a little water. This is used to suspend the powdered stain by mixing it into a paste. Measure the amount of stain needed for one ball of clay, carefully put it into the water, and repeat for each ball. Stir the powder into the water to make a paste – once suspended,

it is safe and no longer a hazard. As soon as there is no loose powder present, you can remove the respirator.

Carefully take a couple of clay balls with added powder paste and squash them together on a plaster bat, mixing them gently until the liquid and clay achieves a more even consistency. If there is colour on the plaster, add a little water and roll the clay over it; it picks it up in liquid well. Wedge firmly for a little while, slicing and re-joining the clay, until the colour is evenly mixed. Once mixed, the clay will last for some months if sealed tightly in a plastic bag.

Jo Taylor, *Pride and Joy Green i*, 2018 height 25cm (10in) This is an example of porcelain coloured with a range of green stains, made into a variety of shapes and assembled at leather hard before being fired once.

COLOURING CLAY

First weigh the desired amount of clay into balls (an example ratio is 500g to four teaspoons of stain).

Make an indent into each ball and add a little water; wearing a respirator, measure out the stain and place into water.

Stir the powder into the water to suspend it; once there is no loose powder, the mask can be removed.

Using a plaster bat or wooden board, gently work the clay to mix in the colour.

Next wedge the clay firmly to ensure an even colour throughout; check by slicing through the middle with a wire.

Make a test tile each time and note the mixture used on the back to create a reference library.

Chapter 7 – Surface Treatment Pre-firing **103**

NERIKOMI

Nerikomi is the Japanese art of forming coloured clay into patterns that are normally sliced and press moulded into dish or plate forms. There are professional makers creating breathtakingly complex and sophisticated work using this technique, but it can be very satisfying even at a basic level. The technique consists of rolling out individual pieces of coloured clay, slicing and stacking them to form a long shape, then slicing vertically many times along the length to create several shapes that are the same. Think of it as slicing up an entire Swiss roll or Battenberg cake.

Lay all the slices together on a cloth, or on a thin slab of plain clay, then roll gently until just one whole slab is formed. This sheet can then be press moulded, very gently, so as not to distort the patterns created. There are many variations of colour and pattern, which can be quite formal, or the coloured clays can be mixed at random to create a more marbled appearance. This is often called agateware and works well with leftover scraps and offcuts. Bear in mind that when using raw clay, the colours will be chalky and pastel in colour, but when fired, the intensity will be quite different.

Sometimes the pattern can be indistinct or blurry – scraping with a metal kidney at leather hard can help clean this up; some makers wet sand after bisque – if the bisque stage is skipped it can be wet-sanded after a single firing to a higher temperature. Wet-sanding using wire wool, a diamond pad or wet and dry sandpaper, suspends any dust created in water so it is not a hazard. It is a safer option than dry sanding, where a full-face respirator is required and a fine layer of dust will be present all over your workspace, which will need wet cleaning.

NERIKOMI

First prepare clay in several colours (porcelain is recommended for purity of colour). Place a coil on to a slab of a contrasting colour.

Wrap the slab around the coil, carefully blending the join. Place on to another slab in a different colour and repeat.

Slice up the whole coil, to create several identical pieces (like a Swiss roll or Battenburg cake).

Arrange the pieces into a pattern on to a clean piece of fabric; they can be interspersed with plain-coloured or white pieces of clay.

Cover with a clean cloth and roll with a rolling pin to create a slab; the clean cloth ensures that there is no contamination from other colours.

Peel away the cloth to reveal the slab and place it into a clean mould. Handle carefully to avoid distortion or finger marks.

Press into the mould very gently and gradually using a damp sponge.

Trim the edge with a craft knife: at the leather hard stage, scraping with a metal kidney can help reveal a sharper pattern.

Creating stripes can be achieved by placing coils of contrasting colours next to each other on a cloth.

Roll with a clean cloth on top and peel away to reveal the pattern; carefully place into a clean mould.

Gently encourage the clay to take shape with a damp sponge; trim with a craft knife.

Offcuts can be wedged together to create marbled sheets.

Both dishes were dried thoroughly then fired once to a stoneware temperature of 1260°C (2300°F).

Chapter 7 – Surface Treatment Pre-firing **105**

DECORATING SLIP/UNDERGLAZE

Slip and underglaze can both be applied to raw clay; underglaze can also be applied to bisque-fired clay. Underglaze is a commercial product that can be purchased from a supplier; slip can also be bought from a supplier or you can make it yourself. Slip is runny clay with added minerals or stains to give colour; white clays such as porcelain give the purest colour. There are several ways in which to approach making slip – a little research will unearth existing recipes or you can experiment with your own mixtures of clay and oxides or stains in varying proportions.

Slip can be made in different ways: adding water to powdered clay; sieving reclaimed slops; buying ready-mixed white slip; harvesting smooth slip created when someone has been throwing on the potter's wheel; or even using leftover casting slip. It is all runny clay to use as a base to add colour. Commercial stains are available in a wide range of colours and are consistent, predictable and mix well together to produce various shades, like paint; for example, mixing red and blue will give purple. Minerals such as cobalt, iron oxide and copper, are strong so very little is required; the colours are often more natural or earthy. Once colour is mixed into your base slip, store it in a lidded container where it will keep for months. If it becomes a little thick just add water; if you leave the lid off and it dries completely, add water, let it soak overnight and stir or sieve to make it usable again.

Slip works best if it has a creamy consistency and it can be applied to wet or leather hard clay. It could be applied sparingly to bone dry clay, but there is a potential issue when adding volumes of wet slip to dry clay. The additional water can cause cracks or breaks through the stress of expansion, especially if there are joins or delicate areas, so it is best avoided. There are many ways in which slip can be used decoratively; what follows is not an exhaustive list and you may discover your own ways to work with this coloured, liquid version of clay.

Painting

The most straightforward way to apply slip is using a brush; it is best to use the type made specifically for ceramics that can be bought from your supplier or online. Often called Chinese brushes, they are normally made from animal hair and hold more liquid than a painting brush, allowing a longer brushstroke. As slip can be mixed like paint, a variety of colours and shades can be achieved, so a sophisticated image can be created. As it is quite thick, a very fine brush is required for details. Large Chinese brushes can be bought, and give a satisfying sweep to cover large areas, for example, when applying a base colour to a form.

This slabbed plate has been painted with slip in three colours: a large brush has been used for the green background, with a watery white layer on top to give depth. A smaller brush is used for the focal image in black.

Following a bisque firing, the plate was clear glazed, which adds depth to the colours. Firing to a stoneware glaze temperature means that the plate is now vitrified and suitable for regular use in the dishwasher and microwave.

Sponging

Any type of sponge can be used to apply slip, creating a mottled effect; a natural sponge will produce a different type of mark to a manufactured sponge. This technique works well when layering colours as a little of the previous colour will show through, adding depth. Used for centuries, this method is still part of industrial production today; sponges cut into shapes give reliable repeat patterns – spots in particular are always popular for tableware.

Slip trailing

This is when a small reservoir of slip is released steadily to form a line, not unlike the way ink is released from a pen while writing. Slip trailers can be purchased from a supplier; some people make them and share techniques online. Commercially made ones vary and some are more successful than others; a thin nozzle is generally helpful for finer detail. They are used by placing the nozzle into the slip and squeezing the bulb to suck the slip up into the reservoir. By squeezing gently and steadily as you move the trailer, the slip is released to form a line or pattern depending on how you move it. A little practice is normally required to get the feel for it – rehearsing the trailing action on to a work surface (which can be wiped clean) or on to newspaper will help.

Slip applied with a sponge gives a mottled affect, allowing a little of the layer underneath to show. A small diddler is used to apply spots of equal size; a brush can be used for applying spots without a mottled effect.

Normally, a base layer of slip is used to create a background colour – slip can be trailed on to it straight away, known as wet on wet, or once it has dried a little. Lines or dots of wet on wet will settle to the same level, whereas adding slip on to a drier base will give a raised pattern. An English potter, Thomas Toft, made large commemorative platters using this technique in the late 1660s and many examples can be seen in museums. The edges of his platters often have lines of slip criss-crossed over each other to make slightly raised grid patterns.

This is an example of a slip trailer; there are many different designs for this function. Slip is sucked up through the nozzle into a reservoir, then it is squeezed slowly and evenly to release a line of slip.

Slip can be applied on to a base layer that is still wet or when it has dried a little; it can be applied in a controlled way or in a more spontaneous manner for different effects.

This platter was made using a fabric mould as seen in Chapter 5; feet were added to elevate it a little and a clear glaze applied, which enhanced the colours. The bright orange was achieved by mixing porcelain slip with a commercially produced stain.

Feathering

You don't have to use a real feather; any reasonably fine point will do! This technique uses a slip trailer (or several) to create lines of different coloured slip alongside each other, all at the wet stage. Normally executed at right angles, a line is drawn across the rows from edge to edge, first one way, then back the opposite way. This drags the slip slightly across towards the next row creating a pattern often seen in traditional slipware (and sometimes on an iced Bakewell tart).

Feathering requires a base of contrasting coloured slips trailed in adjacent lines; it is useful to have more than one slip trailer for this technique!

The feathered effect is achieved by using a point (from a pin, feather or similar) and dragging it across the lines of slip in alternate directions.

A clear glaze intensifies the colour and enhances the effect of the coloured slips moving across one another.

Marbling

Marbling is a random mixing of several colours of slip to create a similar effect to marbled paper. Choose colours that contrast for the best definition – put generous dollops of slip on to the clay surface and shake to see the colours combine. The shaking may be in different directions and more or less vigorous to get the desired effect – a trial run using a tile is useful.

Marbling requires several contrasting colours generously and randomly applied; it can be a messy process, so a contained form is helpful.

The form is shaken, quite vigorously in different directions, so that the slip is mixed and covers the surface consistently.

Once fired and clear glazed, the irregular nature of this technique can be fully appreciated.

Banding

If you have access to a potter's wheel, this technique is much more straightforward than trying to get enough traction from a banding wheel. Line up the work within the concentric circles on the wheel head, have your slip and a brush ready, and apply as the wheel goes round. Judging speed is key – not too fast or you risk it being uneven; too slow and the slip will run out before covering much ground. The consistency of the slip is also key – it's easy enough to add a little water if it is too thick. For each band, a couple of applications is usually required to get consistent colour and pressing the brush evenly each time you apply will help.

Banding is best performed on a potter's wheel: line up the form centrally with the concentric circles on the wheel head.

Different coloured slips are applied with a brush as the wheel rotates; keep the speed and pressure of the brush consistent for even bands.

Once fired and glazed, the colours are intensified and the subtle tones where the bands overlap become apparent.

Combing

This is the action of drawing parallel lines through wet slip. Often, there will be a base layer of colour with another added on top. Wet on wet works well for this method, as the colours settle down evenly. You can use a tool, a fork from the cutlery drawer or your fingers to create marks; again, this is a traditional technique seen in examples of slipware in museums.

Combing is the act of creating parallel lines in wet slip of one or several coloured layers.

A tool or fingers can be used to draw across the surface, revealing the clay body beneath.

Chapter 7 – Surface Treatment Pre-firing 109

Sgraffito

This is derived from an Italian word meaning 'to scratch'; it is also the origin of the word 'graffiti'. It describes the act of scratching through a layer to make a mark and applies to both ceramics and stucco plasterwork. This technique has been widely used, from traditional harvest jugs to the coiled pots of Grayson Perry. The fired colour of the clay body is important, as the use of a contrasting colour of slip over the clay gives the most pronounced effect. Controlling the scratching through is easiest if the clay is leather hard and the layer of slip has dried to leather hard. The top layer can then be neatly incised into, revealing the clay body underneath.

Tools for this technique vary and many prefer the curved blade of the hole cutter, which gives less of a burr than the point of a potter's pin. Looped and metal sculpting tools are also popular – trial and error is required, depending upon how much of the slip layer is being removed and how fine the detail is. Burrs can be gently removed before firing and after, bisque can be wet-sanded with a sanding block or paper, or a diamond pad. This technique is often used for writing text and can range from a simple line drawing to a large, complex composition.

Sgraffito is the technique of making marks by scratching through a layer of slip on leather hard clay to reveal the clay body beneath.

A sharp point is used to draw into the surface – this creates burrs that can be gently removed with a dry brush.

This dish was fired once, unglazed, to stoneware temperature: the two layers of slip contrast well with the white porcelain body.

Mocha

Mocha is an unusual technique that involves mixing oxide with an acidic liquid – traditionally, chewed tobacco juice – but nowadays vinegar will suffice. This mix is dropped on to a layer of wet slip and the reaction causes tree-like patterns to form quickly, which is fun to do and fascinating to watch.

Mocha patterns are created by the reaction when an oxide and vinegar mix is dropped on to wet slip.

Monoprint

This is a way of transferring a drawn image or coloured mark on to clay without directly drawing it on to the surface. It works best on flat clay surfaces and all you need is scrap paper and a point, such as a pencil, pen or similar. Slip is painted on to the paper; it will be shiny at first, but the shine quickly disappears as the paper absorbs the moisture from the slip. Once it is no longer shiny, place the slip side-on to the clay surface and draw on the clean side. The slip will be pressed on to the clay and the marks will adhere. Gently pull the paper away to reveal the image. If the paper is too thin or saturated, the point may go through or you may have difficulty removing it from the surface.

Another way of using monoprint is to draw with slip on to the paper, then as soon as the shine disappears, press the paper on to the clay surface. Gently pull a rubber kidney from one end of the paper to the other, to adhere the design to the surface. Peel the paper away gently to reveal the design. With both techniques trial and error is needed to get the feel of it as different types of paper give different results; it is worth practising on a tile before you commit to the main work.

Monoprinting is the transference of slip painted on paper to the surface of a form. The painted slip needs to dry slightly so it is no longer shiny.

Placing the paper slip side down, an image can be traced or drawn freehand with a pencil or similar pointed object. Be careful not to press too hard and go through the paper.

Gently peel away the paper to reveal the print; be aware that if the paper is too thin or wet it can tear.

A base colour could be used to cover the form, then multiple images can be added in different colours and can overlap if required.

Chapter 7 – Surface Treatment Pre-firing **111**

Screenprinting

This can be done using a ready-made screen bought from a supplier or you can make your own if you have the skills and facilities. It is straightforward to use a screen, gives consistent results and can also be used on bisque ware with underglaze. Place the screen on to the clay surface, paint the slip in neat brushstrokes, giving even coverage and in one direction. Some like to squeegee the slip through the screen or use a sponge to apply it. Once the slip has been applied, peel away the screen and wash it, dry flat and re-use.

Screenprint stencils can be purchased online and used with slip on raw clay or with underglaze on fired clay (see Chapter 8).

By painting slip on to the stencil, a pattern will form on the clay surface, which can be built up in layers if required.

After bisque firing, this porcelain press-moulded dish was clear glazed and fired to stoneware temperature.

Any paper can be used for a resist technique; this doily was dampened with a spray of water to help it adhere to the clay surface and slip was applied with a brush.

For a different effect, masking tape is used and slip is applied with a sponge; colours are added in layers to the pinch pot made in Chapter 4.

Paper resist

Paper resist is used to mask off areas, so that when slip is applied, a shape is left showing the colour of the previous layer. Paper can take the form of masking tape for straight lines, newspaper cut into shapes with scissors for sharp edges or torn for blurry edges. Paper doilies can make interesting patterns; these and newspaper may need a light spray of water to dampen the paper enough to adhere to any contours in the clay. Slip can be applied over the top of the stencil with a brush or sponge and when it has dried a little it can be peeled away gently, perhaps using a pin to prise away the corner of the paper.

This image was sourced online, printed out then cut with scissors before being placed on a pale base layer.

Dark underglaze was applied on to the paper; once it was carefully peeled away, the dramatic contrast was effective.

Wax resist

This is another means of masking off areas, but the wax will not disappear until it is burnt off in the kiln. Wax can be bought as a liquid or warmed to melting point until liquid enough to apply. Wax can be applied with a brush and slip applied over the top. It will quickly

ruin brushes, so keep one especially for wax use. It can also be used to mask off areas on a bisque piece that do not require glaze, either as a decorative design but most commonly to mask the base of a pot being dipped in a bucket of glaze.

Latex resist

Latex resist can be bought from a supplier and works well applied in patterns that use a continuous line. Painted on to leather hard clay, it will need to be dry before slip is applied, so apply it as thinly as possible or you could wait all day. Once slip has been applied and has dried a little, take a pin and free a small area of the latex. As it stretches, gradually pull the whole of the latex mesh away to reveal the pattern underneath.

Wooden stamps

These are mainly purchased to use in creating surface texture, but they can also be used to print with by dipping the stamp into slip then placing on to the surface. Repeat patterns can be created in this way.

Inlay

Inlay is a process whereby a recessed area is filled with a contrasting coloured slip, allowed to dry and then scraped away, leaving a flush surface. Clay is carved away from the surface to create a shallow channel, normally to a specific design or pattern, or sometimes a more freehand approach is taken. This technique works best when the edge cut into the recess is sharp and clear, which will help the definition at the final stage. The recess is filled with slip of one or more colours, depending upon the design, and allowed to dry to leather hard. The level may decrease as it dries so it may need topping up part way through. Once all is leather hard, the surface is scraped using a metal kidney to create a flush, flat surface and the design is clearly revealed. This is how encaustic tiles, in contrasting terracotta and yellow and often found in churches, were created in medieval times and again in the Victorian Gothic Revival period.

Burnishing

Burnishing is the polishing of the clay surface at the leather hard stage to create a shiny surface. Often used in the decoration of traditional African pots, this technique requires the clay to be just at the right stage – it will not work if there is too much moisture present. A pebble or round stone works well, or the back of a spoon can be used, in repeated circular movements to compact the clay particles and create a smooth, shiny finish. It can take a lot of work depending upon the size of the piece, and it takes a little practice to yield the best result; some makers use a little vegetable oil when burnishing. This type of work is normally fired to bisque temperature and then smoke-fired, with a final application of wax to enhance the shine at the end of the process.

This is a summary of the most popular techniques; slip is very versatile as simply, it is just adding runny clay to clay, so you can be reasonably confident in experimenting with it. Most methods discussed can be combined to create surface interest, giving numerous permutations even with just a couple of colours. Once bisque fired, works can be clear glazed, which is recommended for tableware, or unglazed sculptural works can be fired just once to the desired temperature.

Latex resist was applied to this pot at leather hard in a continuous pattern and allowed to dry, then blue slip was sponged over the top. The latex was removed in one piece once the slip had dried a little. Once bisque fired, the piece was clear glazed to stoneware temperature.

As well as being used for impressing into soft clay, wooden stamps can also be used to apply slip to create patterns.

Madoda Fani *Untitled II* (uncarved), 2019, height 43cm (17in) a stunning example of a burnished and smoke-fired surface.

CHAPTER 8

FIRING, GLAZING AND FURTHER TECHNIQUES

Firing is an integral part of the ceramics process. By subjecting the clay to immense heat, the purpose is to transform the clay from raw, brittle material into a permanent irreversible state. This is normally followed by subsequent firings to achieve decorative surfaces using glaze or other creative applications. This chapter offers guidance for bisque and glaze firing, including troubleshooting advice and a summary of different types of kiln firings. Firings are either 'oxidized', where oxygen is present during the firing, or 'reduced', where the oxygen in the kiln is reduced. The focus of this chapter concerns oxidized firings using an electric kiln and is a condensed, practical overview that can be extended with further reading (see bibliography). Decorative techniques that follow a bisque firing are also explored, including an introduction to glaze. As well as giving practical guidance, the contributors share fascinating insights into their approaches and techniques, which encompass finishing with acrylic paint, using ready-mixed glazes, transfers and lustre, and once (single) firing without glaze.

ELECTRIC KILNS

There are several options for getting your work fired – you could pay a local facility to fire your work or it may be included as part of a course or community studio you are involved with. Perhaps you own a kiln or are considering buying one? Electric kilns are the most popular with individuals and educational facilities for several reasons: straightforward ease of use, programmability, even and predictable firings and the option to use renewable energy sources rather than fossil fuels. They can be purchased in a range of different models, either direct from a supplier or second hand, and it can be as easy as taking it home and plugging it straight in. Be mindful that larger kilns require different types of electricity and cabling – a kiln technician or electrician will be able to advise you. There are generally two main types of kiln design: front loader and top loader. A front loader kiln is accessed at the front like an oven, and a top loader kiln is accessed from above by lifting a hinged lid; the choice often depends upon the space available, budget and the size of work to be produced.

As explained in Chapter 1, ventilation is a priority because of the harmful fumes that are emitted during a firing. Always consider where you are siting the kiln to avoid exposure to

Wanying Liang's studio: this sculpture makes the most of every millimetre of space in a top-loading kiln.

◀ Patricia Volk, *Bloom*, 2018, height 90cm (35.5in).

fumes and always seek advice from a kiln maintenance engineer if you are unsure. Always keep a distance between the kiln and the wall – recommendations for a gap are generally 30–45cm (12–18in). It can get very hot around the kiln during a firing and it is important to avoid a fire hazard and damage to your wall from extreme temperatures. Space for easy access around the kiln is essential for any maintenance or repairs.

In terms of maintenance, electric kilns can work quite happily for years depending upon the frequency and temperature of firings. If you think of a kiln as a well-insulated box made of bricks with elements inside it, there isn't too much that can go wrong. The most common issue is the deterioration of elements, causing them to work less efficiently and resulting in the kiln taking longer to reach temperature or even fail to reach it altogether. This can be rectified by replacing elements, which is best performed by someone qualified to do so, such as a kiln technician. Occasionally, the seal around the door or lid can show signs of wear and tear, which can also reduce efficiency; therefore, the insulation may need replacing.

Most modern kilns are operated by a digital kiln controller, which can be purchased as a separate unit and fitted to many types of older kiln. Second-hand kilns can be a thrifty purchase if they are in good condition: always check the bricks inside for damage and examine the door for rust, which will require repairs, so check costs to see if it is worthwhile. The shell of the kiln can stand the test of time if it is little used or has been well cared for, but you may still need to invest in new elements and an up-to-date controller.

An example of a digital controller; this small box fitted to the kiln allows storage of a range of firing programs and will give a temperature readout at every stage of firing.

KILN FURNITURE AND LOADING

Kiln furniture is a collective term for kiln shelves and props used to load the kiln to suit the shapes and sizes of the work you have made. Packing a kiln can be likened to solving a three-dimensional puzzle. The aim is to load and position your work to make the best use of space and achieve optimum efficiency. Approaches vary – you could group works of similar height or if you have awkwardly shaped pieces, you may want to build around them. Always leave the tallest pieces for the top shelf to avoid making unstable stacks of props.

Start with your bottom shelf and place the props in the correct position first. Props need to be spaced out evenly to spread the weight of the subsequent shelves and work. Three props as a triangle works well for a square or rectangular shelf – one at each front corner and the third halfway along the back. With round shelves, having three or four props works well, spaced evenly around the circle. It is important that the props are in the same spot on each subsequent shelf so that the load spreads evenly down the stack.

Your props need to be around a centimetre (half an inch) taller than your tallest work to allow for expansion during firing. Pack the work closely until the shelf is full, and then place the next shelf carefully on top and repeat, putting the props in place first. For bisque firing, it can be more efficient to stack work such as pots, plates and tiles on top of each other (but never for a glaze firing as they will stick). Never allow work to touch the elements as this can cause damage to both. Try and pack evenly to allow good air flow.

BATT WASH

To protect kiln shelves and get the longest use possible, it is advisable to coat them with a layer or two of batt wash (also called shelf primer). This liquid substance is either brushed or poured on to the kiln shelves to prevent glaze or the work sticking to the shelf and causing damage to both. It adds a thin protective layer that can be chipped away and reapplied as necessary, for example, if glaze drips on the shelf. Batt wash can be purchased from your pottery supplier or you can make your own by mixing 50 per cent Alumina Hydrate with 50 per cent china clay, or kaolin. Always wear a respirator with filters when handling ceramic powders – a disposable dust mask is not sufficient. Add water to the powder mix; you may need

When loading the kiln, start with the bottom shelf, put the props in place first, then carefully load the work. Grouping work of a similar height is helpful.

Build up each layer with a new shelf, keeping the props in the same position every time so that they form a continuous line of support.

The view through the door of a front-loading kiln after a bisque firing: note that tiles are stacked on top of each other as work can touch in a bisque but not in a glaze firing.

to sieve the mixture to get a smooth consistency, and aim for a thickness as runny as single cream. Once the powder is suspended in water it is safe to remove the mask – airborne particles are the issue, which links to the wet cleaning routine described in Chapter 1. After the batt wash has been applied, you can either bisque fire the shelves to 'bake' it on, or you can place your work directly onto a raw batt washed shelf, depending on your preference.

BISQUE FIRING

The first step is to bisque fire your work, after which it can be handled without breaking and still be porous enough to accept glaze. The temperature of the kiln increases gradually to around 1000°C or 1830°F, which turns your work from recyclable clay into fired ceramic through a chemical change in reaction to the temperature. The bisque firing is often the first of two firings, the second being a glaze firing.

Prior to bisque firing, the work must be completely bone dry – commonly called the 'green' stage. If a piece is not sufficiently dry, any moisture trapped within the clay will vaporize as steam when the temperature in the kiln exceeds boiling point (100°C or 212°F). This creates a build-up of pressure, which can put your work at high risk of exploding or disintegrating during the firing and can also damage other work nearby in the kiln.

To ensure your work is dry enough to fire, first carry out a visual check as the colour of clay changes from dark to light as it dries. Bear in mind that if the work is uneven, thicker areas will take longer to dry. Despite looking dry at first glance, areas that are still damp within the clay will feel cold. If it is possible to feel the work by pressing it against your cheek, you can easily tell if it feels cold.

If the work does feel cold, it will need longer to dry out in the room, or you can speed up the process by using a drying cycle once the work is loaded into the kiln. This is often used for larger, thicker pieces or sculptural work made on a kiln shelf, so you cannot feel the base easily. A drying cycle is the process of gently heating the work at lower temperatures for hours at a time to ensure thorough drying all the way through the work. Think of it as like putting a piece outdoors on a hot, sunny day for the afternoon. An example would be to take two hours to slowly reach 60°C (140°F) and 'soak' (stay at the same temperature for several hours), then increase to 90°C and soak again. The cycle needs to ensure that a thorough drying process has taken place; the cycle required depends very much upon the work being fired.

If your work is bone dry and loaded or you have already used a drying cycle, then you are ready to bisque fire – you can program this to happen automatically straight after a drying cycle if you wish. Make sure the top vent is open to allow steam, chemically combined water, combustible material, sulphur dioxide and other chemical compounds to escape, which prevents them causing damage to the inside of your kiln. Room ventilation is vital, so ensure any extraction system is functioning and windows are open in the studio or kiln room as soon as you switch the kiln on. The top vent, or damper, will need to be closed or bunged when the kiln reaches around 600°C, or 1100°F: this is a critical temperature when clay goes through a chemical change as the bonds within its structure

become fixed and irreversible. Once the vent is closed, the kiln will be more efficient in reaching the target temperature as minimum heat is escaping.

An example for programming an average bisque cycle would be for temperatures to climb at a rate of 60°C (140°F) per hour until it reaches 600°C (1112°F) when you close the bung, then 100°C (212°F) per hour until it reaches 1000°C (1832°F), totalling fourteen hours. It will then take a similar time for the cooling down process, depending upon how well your kiln is insulated – some very well-insulated ones can take several days. You can adjust this program to reach the temperature faster by increasing the temperature per hour for the second stage; if you have smaller, thinner works that are thoroughly dry, it would be safe to do so. If you are intending to glaze work in a second firing, it can be beneficial to 'soak' to the end of a bisque firing, depending upon which clay you use; this is always advisable with porcelain. A soak is where the temperature remains constant for a short period, usually ranging from fifteen minutes to an hour, which helps to burn out any remaining impurities or organic matter that could cause technical issues in the glaze.

If you are using a stoneware glaze, bisque firing to 1000°C (1832°F) will be sufficient – the fired clay will remain porous after this firing and it will absorb glaze easily. If you are using an earthenware glaze firing, a higher bisque firing in the range 1120–1140°C (2048–2084°F) is recommended to make the work less porous and therefore more durable. The only issue is that it may not absorb glaze as easily – if there are any issues, warming the work before glazing will help. To remember this, here is a handy guide: low bisque = high glaze firing, high bisque = low glaze firing.

The joy of kiln controllers is that they switch the kiln off automatically when it reaches temperature, so all you have to do is switch it on, then close the vent at around 600°C (1112°F). Leave the kiln well alone to cool – the controller will show the inside temperature – and it can feel as though it is taking forever as it cools rapidly to start then slows down, so the latter stages can be frustrating. Do not be tempted to open the bung or door as a blast of colder air can easily damage work and escaping heat will be hazardous to you.

There are various schools of thought on when you can finally open the kiln. Ideally, leave it until 80°C (176°F) before opening the top vent to help it cool, then gradually open the door slightly to allow the air to circulate. It would be ideal to unload the work when it has cooled enough for you to comfortably hold it, although many will unload it sooner using heatproof gauntlets. It depends upon how much time you have – if kilns are under pressure to be reloaded or there are deadlines to be met, the process is often hurried along – ask a technician! Never rush opening the kiln for a glaze firing as work can crack and break at a relatively low temperature because of the extra tension of cooling the glaze as well as the clay body.

PYROMETRIC CONES

Pyrometric cones are slim pyramids of ceramic material that soften and bend at specific temperature points, providing a cheap, accurate way to record what temperatures are being reached in different parts of the kiln. This can be particularly useful as the kiln gets older, or if you think there may be a problem reaching temperature. Your kiln controller displays the temperature taken from the thermocouple inside the kiln, but sometimes this may not be accurate; it depends upon the condition of the kiln or the thermocouple, or its location. Pyrometric cones are very small and can be purchased from your pottery supplier or online. They range across different temperatures and makers often work with three of them: the one nearest to the temperature you are firing to, one at the temperature below, and one above to help ascertain if it is over or under firing. Placed in different locations inside the kiln, normally top and bottom shelves, cones arch over completely when they have reached their specific temperature. If they have entirely melted, they have reached beyond that temperature and if they are slightly bent or remain upright, they have not reached it at all.

Pyrometric cones are wrapped in a small coil of clay to keep them upright and placed on a kiln shelf away from any work that could be touched when they arch over.

These cones were placed on the top and bottom shelves: they have arched over during firing, illustrating that the temperature was achieved and consistent in both locations.

Before placing them on the kiln shelf, stand each cone upright firmly on its base and wrap a small coil of any raw clay around the bottom to make it stable. When placing the cones, ensure they are a reasonable distance away from any work they may touch as they bend over. Place them in the kiln and note what you have placed where, so you can make sense of the results several days later. The information gleaned from cones can help diagnose a fault, or you may simply adjust your top temperature to accommodate more minor anomalies. Pyrometric cones can also be used in conjunction with kilns that shut off automatically when the cone has arched and reached the required temperature.

Another way to accurately read the temperature during a firing is to use a portable kiln thermometer, which can be purchased as a battery-powered unit with a long thermocouple. This is inserted into one of the kiln vents before firing to read temperature at that location – you may need to pack around it with kiln wadding (from a pottery supplier) to prevent heat loss as the firing progresses. You can check the temperature at various points during the firing and compare with the read-out on the controller. Sometimes there is variable temperature near the peak temperature; this is useful information that enables adjustments to be made to the top temperature of your controller to compensate.

UNDERGLAZE, ENGOBES AND VITREOUS SLIP

Vitreous slips, decorative underglazes and engobes can be made following a specific recipe, or purchased ready-made as a liquid in a jar in a range of colours from a pottery supplier. Commercially produced underglaze can be applied directly to both raw and bisque-fired work. As well as providing a blanket coverage of work, it enables you to create a runny wash to highlight texture and detail, or you can use it to screenprint, stencil or paint on a design with a brush.

Engobes, or vitreous slips, are designed to be applied on to bisque-fired work. They differ from decorating slip, which is applied to raw work, as there are a couple of ingredients that make it halfway between a slip and a glaze. The results will not be shiny, but engobes or vitreous slip can expand and fit the work well when fired at a higher temperature. This can suit work requiring a matt finish; an application can add depth, texture and colour, often effective for sculptural work. Ceramic pencils and crayons can also be purchased from a supplier, or it is possible to make your own crayons; they can be used to draw directly on fired clay and appear chalky in texture. It's useful to have already given the work a coating of white slip at raw stage to help the colours apply well on to a smooth base and to show up well on a white background. Clear glaze can be applied directly over any of these decorative methods for a glossy finish, or you can fire it unglazed for a matt surface.

A tile with a layer of white slip has been bisque fired; a screenprinting sheet is placed over it and painted with black underglaze.

The screen is peeled away, revealing the pattern beneath. The stencil is washed and laid flat ready for use at a later date.

The printed tile is taken straight to a tray of clear glaze where the whole surface can be placed evenly on to the glaze.

The tile is dipped carefully, ensuring that the glaze contacts with one side only: now it is ready to fire.

Chapter 8 – Firing, Glazing and Further Techniques

A tile with a layer of white slip has been bisque fired; the slip creates a clean background to draw on with an underglaze pencil.

A layer of clear glaze was applied straight on top of the pencil marks and fired to stoneware temperature.

GLAZE

Glaze provides a multitude of options for colour and surface to finish a piece of work. The choice can be related to practical considerations for functional ware or to provide a particular surface or colour for a sculptural piece: the possibilities are almost endless. It can be purchased ready mixed; you can simply open a jar of liquid and brush it on to your bisque ware or you can buy a bag of powder, which is added to water and sieved to make it ready to use. The advantage of using commercially prepared glaze is that it will come with comprehensive health and safety information, firing instructions and images of how the fired glaze will look. Deciding what glaze to use can be overwhelming and most makers settle on a selection of tried and trusted glazes that suit their work.

Glaze recipes are used by many makers – some are guarded secrets as they are a maker's personal signature for their work – but often tried and trusted glazes are shared within the ceramics community, published online or in a book for all to use. Raw ingredients can be bought, weighed in proportions as stated in the recipe, then added to water and sieved. Sieves for this purpose can be bought from a supplier and come in various grades, depending upon how fine the glaze needs to be. As a rough guide, most glazes work well with around 60 or 80 mesh. Remember that when handling ceramic powders, you should always wear a respirator mask and clear up any loose powder spills promptly with a damp sponge.

Understanding the terms 'earthenware', 'stoneware', 'reduction' and 'oxidization' will help you choose the right glaze for your work and kiln. Earthenware and stoneware are often stated in relation to clay and glazes and refer to the top temperature the work will be fired to.

Earthenware is fired at the lower of the temperatures, where work is glaze-fired to around 1080°C (1976°F). This uses less energy and the firing cycle is quicker; in the past, this has meant colours would be brighter although this has changed as materials have developed. The disadvantage is that the work will retain some porosity, which affects its ability to handle thermal shock and makes it unsuitable for leaving outdoors in

Mixing up powdered glaze: always wear a respirator mask, add the powder to water (to lessen airborne particles) and stir to achieve a creamy consistency.

Glaze is sieved to eradicate lumps and achieve an even consistency: it is pushed through the mesh with a rib or stiff brush into a container. The rolling guides are useful for balancing the sieve!

Chapter 8 – Firing, Glazing and Further Techniques

the frost, or for regular use in the dishwasher or microwave. It is also more prone to chip or crack with regular use as it is less durable, so is better suited for lighter use and washed by hand, or decorative work for indoor display.

Stoneware is fired at the higher of the firing temperatures, where work is glaze-fired from 1200°C onwards, with typical firing points at 1260–1280°C (2300–2336°F). This firing ensures that work is vitrified and no longer porous, so is suitable for outdoor display and tableware used regularly in a dishwasher or microwave. The firing cycle will be longer and uses more energy, so it is slightly more costly to produce.

Oxidization and reduction refer to the type of atmosphere when the kiln is firing and how much oxygen is present. Oxidization is always the type of firing achieved in an electric kiln – no combustible fuels are used and there is oxygen present throughout the firing. Reduction firings happen in a kiln where combustible fuels are used, like gas or wood, and the oxygen supply is reduced by closing vents, or dampers, causing the flame to take oxygen from the clay and glaze. It is possible to have an oxidized firing in a gas kiln, but not to have a reduction firing in an electric kiln. The same work can look very different fired in different types of atmosphere; for example, a glaze made with copper oxide and fired in an oxidized atmosphere will result in green, compared to blood-red in reduction.

'Food-safe', 'dinnerware safe' or 'lead-free' are often seen on labels of ready-mixed glaze; it is important to use only this type of glaze if you are making work used for food or drink. Historically, glazes often used ingredients such as lead; it was subsequently discovered that using this type of glaze with acidic food such as vinegar or fruit juice would cause lead to leach from the glaze into the food. Health and safety in ceramics has seen many changes and the development of food-safe glazes has thankfully eliminated this issue. Glaze and glaze ingredients will always be labelled if harmful and if you are unsure, your supplier can advise.

Some glazes are intended for specific types of firing or require expertise, such as reduction glazes for a gas or wood-fired kiln; raku, which requires a raku kiln; and crystalline, which requires a specific firing cycle in order to grow crystals within the glaze. As your skills and knowledge progress, you may wish to explore these techniques as part of your development. Enrolling on a course or a workshop is a great way of accessing and experiencing this first hand.

APPLYING GLAZE

Glaze can be applied to bisque work in several ways, depending upon the size and complexity of the pieces you are glazing and how much glaze you have available. Always stir glaze immediately before you start applying, as heavy particles will sink to the bottom of a container, leaving clear water at the top and this needs to be mixed to an even consistency. You may need to add water, or skim some from the top before you mix it up, to get it right. A common analogy is to liken the mix to single cream consistency for earthenware glazes; stoneware glazes need to be a bit thicker, like double cream. For accuracy and to maintain uniformity, some makers use a viscometer.

Ready-prepared glazes purchased in liquid form come in a plastic pot or tub, and normally carry instructions to apply with a brush for two or three coats. It is best to use a brush made for ceramics, often called a Chinese brush and made from animal hair as they hold liquid more effectively than a paintbrush, and make application smoother with better coverage.

If you have mixed your own glaze from a recipe or added water to a powder and have a bucket available, a slow, steady dip of the work will give even coverage. Hold firmly with the tips of your fingers and submerge gently. A dab of glaze to any area left blank by fingertips will ensure even coverage. You may need to dip in two halves depending upon the shape, or dip twice to get enough thickness. Practice helps and if it goes wrong, you can just wash off the glaze, dry the piece thoroughly and try again. If you have access to a spray booth you can use a relatively small amount of glaze to give an even application as the work is rotated slowly on a banding wheel. Always wear a respirator if using a spray gun as fine particles of glaze are released into the air.

It can be hard to judge how thickly to apply as glazes vary widely, but 1–2mm (0.04–0.08in) is about average. Checking thickness can be tricky, but a good way to judge is to push a sharp pin through the glaze to the fired clay to see how much of the pin disappears. Once it is dry, check to see if there are any runs or drips in your glaze that will make it uneven in the firing. You can very gently shave away any protrusions, a little at a time, with a metal kidney or thin knife. Do not be tempted to pick off a lump in one go or it can break away an area, leaving a gap in the glaze. If you have any pin-sized gaps in the glaze application from little bubbles, gently rub the surface of the glaze with your finger in a circular motion which will smooth the craters into an even surface.

Finally, it is very important to wipe the base of your work clean with a damp sponge. This is to ensure that it will not stick where it touches the kiln shelf; as some glazes can run, you may need to wipe away a little way up the sides to allow for this. Some makers coat the bases of their work with wax, which is brushed on to the work as a warm liquid prior to glazing, or is purchased as a liquid from a potter's supplies. When applied, the wax will repel the glaze, so there is no need to wipe away glaze from the bottom of the work. Load works the same way as with a bisque firing except work must not touch other pieces, kiln props or elements or it will stick solidly and be ruined.

Once loaded, the kiln can be switched on and the firing cycle started without the need to fire slowly at the beginning; all of the matter contained within the clay has already been burnt off in the bisque firing. The bung will need to stay open while water and other matter in the glaze burn out. Then, as with the bisque firing, put it in at around 600°C (1112°F). Suggestions for glaze firing cycles vary, but normally, they climb between 80 and 100°C (176 and 212°F) per hour up to 600°C (1112°F), then between 125 and 200°C (257 and 392°F) until the top temperature, which will be around 1080°C (1976°F) for earthenware and 1260–1280°C (2300–2336°F) for stoneware. A brief soak, or hold, of around fifteen minutes is recommended for all glaze firing, as it achieves a more even glaze surface as any bubbles have the chance to burst and settle. The purpose of a soak is to bring both the clay and glaze to the point of maturity for optimal results.

Firing cycles can vary, depending upon the glaze you are using – ready-mixed glazes will have clear instructions. If you are making your own glazes from scratch following a recipe, further reading is recommended to help you develop and achieve an exciting range of glazes, which, in turn, could become your signature style. In both cases, it is wise to conduct tests prior to glazing your main works to help you gauge the final outcome.

Ready-mixed glaze, purchased as a liquid in a pot, can be applied directly to bisque ware with a brush.

A larger brush will give greater coverage as it holds more liquid; they are often labelled Chinese pipe brushes or glaze mops.

This celadon glaze is made from a recipe (ingredients listed at the rear of the book) and the inside of the jug is being glazed while the outside is left unglazed.

This is the jug following a stoneware glaze firing; the raw glaze gives no indication of the final colour that will be achieved. The colour contrasts well with the surface of the porcelain clay body.

Chapter 8 – Firing, Glazing and Further Techniques 123

OXIDES/GLAZE STAINS

Oxides and glaze stains are concentrated ceramic powders used for adding colour to glaze, and also to slips and clay, as discussed in previous chapters. Oxides are very concentrated so just a small percentage will add colour to a relatively large volume of glaze; be aware that the colour of the oxide in its raw state will differ to the eventual colour of a fired glaze. Popular oxides are cobalt, which gives a classic blue; iron oxide, which comes in black or red for rich browns; and copper for greens, or reds in a reduction firing. Stains are manufactured pigment produced by the ceramics industry and offer consistency; the colours in their raw state are good indicators of the final outcome.

Oxides and stains can be added to water to paint on top of glaze; some recommend using tea instead of water as the addition of a small amount of organic matter gives better suspension. The classic example of painting oxide on to glaze is in Delft ware, inspired by the Chinese tradition of brushing cobalt on to porcelain. This technique can be achieved by painting diluted cobalt oxide on to work that has been dipped in a white glaze, often labelled as 'tin' glaze. Oxides mixed with water can also be used to enhance depth and texture directly on to the clay surface by applying a diluted solution to the work then wiping away excess with a sponge, leaving the oxide present in the recesses of the work. Oxides are also useful for labelling or signing work underneath as it does not stick to the kiln shelf.

The tiles have been dipped in a white 'tin' glaze and cobalt oxide mixed with water is used to paint directly on top of the glaze.

Once fired, the cobalt is fixed into the surface of the glaze and the beautiful blue colour becomes apparent.

Cobalt oxide mixed with water has been applied to this tile, then the surface has been wiped with a damp sponge, leaving oxide in the recesses.

Chapter 8 – Firing, Glazing and Further Techniques

Stains are useful for adding to base glazes to change the colour, especially if you seek bright colours that 'pop' compared to the more tonal qualities produced by an oxide. A basic clear glaze can be changed to any coloured glaze by adding oxides or stains: in the region of 0.25–3 per cent for oxides and 2–12 per cent for stains. The more you add, the more intense the colour, but always take notes of weights and measures when experimenting to repeat successes and avoid repeating disasters.

This slab-built planter from Chapter 5 has been glazed with a white 'tin' glaze.

The same glaze with added pink stain has been used to glaze the extruded sculpture from Chapter 6.

These wall pieces use a commercially produced clear glaze with added blue stain to contrast with the unglazed white porcelain: the right-hand piece had a stronger percentage of stain added compared to the left.

Chapter 8 – Firing, Glazing and Further Techniques

ONCE FIRING

Firing work just once is a quick and economic approach to producing work. Single (once) firing with glaze works best for smaller pieces with simple shapes – the glazes are specific to this method and application can be a little tricky due to the fragility of raw work. Research is needed to find the best approach, but there are many makers having success working in this way, often sharing their recommendations online.

Single firing without glaze is often used for coloured clay, as with the Nerikomi technique, which uses multicoloured porcelain. Taking clay to stoneware temperature in a once firing ensures that the clay is vitrified, making work suitable for outdoor display, so also suits larger sculptural works.

ENAMELS, TRANSFERS AND LUSTRE

Enamels (also called over glaze, on glaze and china paint) and transfers are applied to fired, glazed pieces, so using these techniques requires a third firing after bisque and glaze. Enamels can be bought ready-made and in the form of a brush-on liquid or a pen to draw on to a surface. They can also be bought as a powder and mixed up with oil or medium to be applied, or often in industry, screenprinted on. Colours are bright, shiny and it does not run like some glazes; historically, this was the means used to achieve bright colours and apply pattern industrially.

Transfers can be bought ready-made, or you can create your own design, which you can then scan or prepare digitally and send to a company who will print it for you using enamel-based ink. Cut neatly around the transfer and immerse it in water and within five to ten minutes the backing paper will soak and start to come loose. Very gently slide the transfer away from the

These transfers were made from drawings scanned and sent to a company who printed them in transfer format using enamel inks.

Ready-made stock transfers can also be purchased; this willow pattern image was bought online. The transfer is soaked in water to release the backing paper.

The backing paper can be removed once it has loosened off, and the transfer placed on to glazed work.

The transfer is smoothed on to the work using a rubber kidney and excess water is removed with a sponge before the third and final firing.

paper, keeping it the right way up, and apply directly to your glazed work. Using a damp sponge or rubber kidney, smooth the transfer from edge to edge, ensuring there is no water or air trapped underneath; be gentle as transfers can be fragile and may crease or tear. Enamels and transfers are typically fired to around 820°C (1508°F); always check the manufacturer's instructions. Depending upon the type of enamels used, a firing could smell chemical, transfers less so, but always ensure your kiln is well ventilated to deal with any fumes.

Lustres can add sparkle to your work – highlighting an area in gold or any other metallic lustre is another layer you can add on top of glaze, or glaze with enamels. Bought in small bottles ready-made, and relatively expensive, they apply thickly like nail polish, but can be diluted with thinners, which are also used to clean your brushes. Brushes can be ruined quite quickly, but if you apply liquid soap to your brush before use it can help prolong its life a little. Wearing a respirator mask during application is recommended as the fumes are quite strong; gloves will protect your hands from coming into contact with any harmful chemicals.

Lustres require a further firing to a different temperature, in the range 700–800°C (1292–1472°F) or precious metal lustres 820°C (1508°F); again, check manufacturer's instructions as products vary. Similar to enamels and transfers, it can be a fast climb with a brief soak, so constitutes another relatively short firing. This could be the fourth firing if you take the route of bisque, glaze, transfers or enamels, then lustre, which can impact on costs, time and energy consumption. Again, continue to be mindful that fumes from firings can be strong so good ventilation is essential.

TROUBLESHOOTING

Ceramics can be unpredictable; this section is an overview of common technical issues and how to resolve them. After the final firing you may occasionally find rough or sharp bits on the work, especially on the base, which may have picked up some bits of batt wash or other material. Small unwanted anomalies can be ground off using a diamond hand-finishing pad, which leaves a smooth surface. They are often used for grinding granite or marble and can be bought online or from a tool supplier; use with water to avoid creating dust.

Be aware that dusty bisque ware can cause issues that show up in the glaze firing. Glazing straight after unloading a bisque firing or wrapping it in plastic if storing for a while will help to avoid dust settling on the work. Greasy bisque ware can cause similar issues – be aware of how much you handle it or wear protective gloves to prevent grease from hands transferring to the work. Crazing can be caused when the glaze doesn't 'fit' the clay – check the firing ranges of both your clay and glaze to check they are suitable for each other.

Over-firing can cause the glaze to boil and form blisters. To remedy this, use pyrometric cones to check the exact temperature the kiln is reaching; the true temperature may differ to the readout on the digital controller. Cracks in a glaze firing can be caused by cooling too quickly so do not be tempted to open the vents or door too soon.

TYPES OF KILNS AND FIRINGS

As well as the popular electric kiln for oxidized firings, there are many other types of kilns and firings.

Gas kilns are widely used, running on mains or bottled gas, and with a little knowledge can be straightforward to use. Most are controlled manually, so the user is more active in the firing process, although digital controllers are available. They suit makers who work with reduction glazes, achieving effects that cannot be reproduced in an electric kiln; further reading is recommended as some expertise is needed to ensure safe and accurate operation.

Gas is also used for raku, which translated from Japanese means 'comfort', but is often heard to mean 'happy accident' in relation to the spontaneous nature of the results of this type of firing. Work is bisque fired and glazed in a specific raku glaze, then placed in a raku kiln and heated rapidly to around 1000°C (1832°F). It is then taken out of the kiln using long tongs and plunged into sawdust, then water. This rapid reduction and thermal shock causes exciting reactions and crackles within the glaze, blackens the clay body and can be quite a spectacle to watch. The extreme thermal shock means there is a risk of losing work to breakages, and there are obvious potential hazards, so safe processes and protective equipment are essential.

Traditionally, kilns were fired by wood and makers still build and use wood-fired kilns to create a specific type of reduction atmosphere to give signature glazes. Salt and soda glazing can be achieved in a wood or gas-fired kiln and gives a speckled 'orange peel' type of effect, often a rich brown or blue in colour.

Salt or soda is introduced during the firing and stays present in the kiln, affecting future firings, so it is recommended to have a separate kiln for this type of firing. Many makers build their own kilns specific to location, dimension or preference; this requires considerable expertise and experienced support, so detailed research is recommended.

A very basic type of firing needing little equipment or expertise is smoke or pit firing; both consist of a chamber and combustible material. The chamber can be a pit dug into the earth, or a metal dustbin – some basic research is recommended to yield the best results and observe safe practice. Bisque-fired work is placed into the chamber and surrounded by combustible materials, such as newspaper, bits of wood and sawdust. After lighting a fire, a metal lid is placed over the chamber to slowly build heat over several hours. This is best left alone to burn and smoulder; it should be completely cool before being removed. Effects can be achieved by placing different materials in and around the work – for example, interesting marks can be achieved using masking tape, fruit peel or seaweed.

Visitors to major ceramics festivals can view an array of kilns in action, including theatrical firings using materials such as glass bottles and shopping trolleys built into kilns. Both the building phase and the spectacle of red-hot flames are fascinating to anyone interested in working with clay. Mainly seen in China and Japan but occasionally built elsewhere as a project or for a festival, are Japanese Anagama (meaning 'cave') kilns, or Chinese 'Dragon' kilns. Often built into a slope, a fire is lit at the bottom and the heat and airflow is drawn through the kiln to the chimney at the top. Continuously stoked with wood to sustain the heat for several days, they were traditionally shared between potters. There are many variations of types of kilns; even if you are happy with a straightforward, reliable electric kiln, it may be interesting to visit a festival or try a workshop to experience other ways of firing.

CONTRIBUTORS

In this final chapter the makers discuss a variety of approaches to the drying, firing and finishing stages. Processes vary and most makers settle to work with a selection of reliable finishes which can be varied to suit; this brings cohesiveness to a body of work and becomes part of a maker's personal signature.

Mark Draper on drying:

> Drying out depends on the time of year and temperature in the studio. I like to give the pieces a very slow drying out; therefore, in the summer they will go in to plastic bags with a few air holes. The models are usually about 6–8mm (0.25in) thick; I leave them for two weeks to dry at least, often for longer. They stay on shelves in my studio while drying. When dry, wearing a mask, I use very fine sandpaper to clean the edges; it's important not to get too obsessed at this stage as fine detail can easily and accidentally be damaged. Ornamentation to parapets, such as small statues, urns and finials, are dried out separately and pegged and glued on to the piece after firing.

Eusebio Sanchez also takes great care with the drying stage of his large, coiled works: 'I try to dry my works for at least three weeks or longer. If I am close to a deadline, I will slow dry a work in the kiln for a whole day – it's like being in the sun without a draught.'

Mark Draper, detail from the ceramic model of Hawkfield Lodge, the lost Elizabethan folly from the Rushton Hall estate, 2018.

Not all makers invest in a kiln; Mark Draper discusses his decision:

> When I started making architectural ceramics, I decided not to invest in a kiln. I wasn't sure if I would stick at it. I have my pieces fired for me at a local pottery materials and kiln suppliers: I've made 195 models over a ten-year period, which works out at about 1.5 models a month. It wouldn't have been cost-effective to buy my own kiln.'

Ready-mixed glazes are a popular and convenient choice for many makers, including Lynda Draper: 'I use a combination of various commercial glazes and underglazes. Sometimes I use lustres and enamels after glazing works; it is dependent on the work.' The reliability of ready-mixed glazes is important for Claire Partington: 'I use shop-bought glaze – I don't make glazes; generally, I use earthenware lead glazes, which are forgiving. They crackle a little, but they are always reliable and I'm happy with the result. It always works and it's easy to put on.'

Eusebio Sanchez, *One Legged Journey*, 2019, height 35cm (14in).

Lynda Draper, *Tiara*, 2015, height 30cm (12in).

Claire Partington, detail of finished figure created for the *Taking Tea* installation for Seattle Art Museum, 2018.

Chapter 8 – Firing, Glazing and Further Techniques 129

Dirk Staschke offers useful advice:

> The majority of my glazes are store-bought and altered with stains. My advice on glazing is to find several glazes you like (mixed or store-bought) and then try every possible combination of overlapping in firings. Two coats glaze A over two coats glaze B on through C, D, E, etc. Also try them on your clay body; your clay body with a white slip; and your clay body with a dark slip. Try to test a new glaze or combination of glazes every time you fire. You will have a lot of 'mistakes', but eventually a piece might call for that particular mistake.

Liking his glazes to run for a more fluid effect, he adds flux to commercially prepared glazes to engineer more flow. Works can be fired several times to facilitate overlapping glazes and the use of china paint (also called over glaze or enamel) and lustre.

Unglazed clay body is an important part of the finished work for many, including Mark Draper:

> For most of my projects, I use Valentines V9a stoneware clay. The fired colour is ideal for the stone buildings and I can add colour, which is fixed on in the second firing. I usually paint a solution of manganese oxide on to the piece which I then wipe off, leaving darker areas in the recesses. This defines the modelling and detail. Where I need to add colour, for example, to the roofs and painted details on the buildings I use Mayco and Amaco velvet underglazes. I have been using a pewter glaze for the windows as it gives a slight metallic and reflective sheen when successful.

Dirk Staschke, *The Structure of an Image*, 2017, height 109cm (43 in) front and rear views.

Mark Draper, detail of ceramic model based on Cliveden House, 2020.

130 Chapter 8 – Firing, Glazing and Further Techniques

Madoda Fani, *Large Smoke Fired Vessel I*, 2017, height 52cm (20.5in).

Wanying Liang, detail of *Woman as Vessel* series, 2020, length of each approx. 43cm (17in).

Paul Briggs, pinched vessel from *Windflower* series, 2013, height 29cm (11.5in).

Underglaze is also used by Madoda Fani for his unglazed coiled works, which are smoke-fired and polished to achieve their beautiful surface. He has spent time studying with established makers to learn the traditional techniques of smoke firing and burnishing:

> I don't use glazes any more, I use under glazes, which you just buy from the shop as they are. I will fire my piece in an electric kiln up to 1000°C, or 1830°F. Once it is out of the kiln, I carry out the smoke firing. I take the piece and put it in a steel drum, stuff it with newspapers and light it. If I want my piece to become very dark, I will keep adding more newspapers while the fire is still on. When I am happy with the result, I will take it out, apply floor polish and polish it up until I am happy with the shine.

Wanying Liang discusses her decision to work in white:

> The surface of my work is simple: I use pure white glaze in most of my works. White is a powerful colour conveying forgiveness, pure and infinite. It is also a colour to embody the cultural difference. For example, Asians use white at a funeral, while the Western world uses white at a wedding. To me, white is a colour that looks simple visually, but has rich meaning. The decoration of my works relies more on the delicate details of flowers and patterns. In most cases, they are handmade. I like the making trace left on the clay. It mimics the natural texture and keeps the maker's imprint, making the works livelier and warmer to people.

The mark of the maker forms part of Paul Briggs's integral surface treatment: 'My decorative technique is also pinched; I'm able to distribute clay as I hand-turn the clay upward by skipping over rows of clay and teasing it out. I formulate my glasses, so I get glazes that pool and break to emphasize the pinches in the clay, but I think the unglazed pieces are more compelling because every fingerprint is retained from the process.' This has evolved in some part by accident:

> I'm actually in a very strange place in my work right now because my tried-and-true clay had a change in one of the ingredients, which threw off my glazes, but I've always felt that the unglazed pieces were the most intriguing because the entire process remains documented. The pieces truly are more vessel than pot and probably more sculpture than vessel, especially in the early windflower series that tilted to the side. This is an expression that I'm revisiting and trying clays that do not have to be glazed, but are very vitrified. I think I'm going to lean in that direction and towards atmospheric firing such as soda.

Jo Taylor, *Vari Capitelli vi*, 2020, height 43cm (17in).

Natural texture is also a concern for the author:

> I fire all of my work once to 1260°C (2300°F), whatever clay I am using, from black heavily grogged to porcelain. I enjoy the economy of firing once, saving time, money and energy. I do not glaze my work for several reasons, primarily because it is sculptural so glazing is not essential. I spend a lot of time making additions by hand. These are fixed to a structure, so there is a lot of detail around the form. There are many marks made by hand and tool, and the shadow and light around these areas form an important part of the work. When experimenting initially, I found that glaze adds a layer that acts as a barrier and can draw the eye away from all of the detail I have spent time creating. A shiny glaze reflects the light, which works against the shadow and contrast I am interested in, so it contradicted my intentions. I also like the fired surface of raw clay; porcelain in particular has beautiful qualities when fired 'naked'.
>
> The colour in my work comes from mixing stains into the clay before I start making. While I know roughly what it will look like from previous work and tests, I change things around regularly so can be unsure exactly how the work will look until it is fired and the true colour develops. Modern glaze stains work well at high temperatures; previously, brighter colours only worked well at earthenware temperatures so I am very grateful for this development. This allows the work to become vitrified in a stoneware firing so it is more robust for outdoor display, and in general.

The development of coloured stains is also significant for Eusebio Sanchez:

> I love colour – historically, ceramic colours could be limited, but now you can achieve anything with stains. If I can, I will use a colour you're not used to seeing in a ceramic work. I love yellow – shades of yellow to green and to orange – it feels like an antidote to what is happening in the world. Work is fired, then I use an engobe on bisque and re-bisque, and then glaze on top. I find engobe recipes online and tweak them, to help achieve very bright colours.

I've carried out a lot of testing to try different glazes together to see how they work; initially, they clashed, but now they are bit more harmonic. I layer glazes on top of each other – there can be up to six different glazes on one piece. Generally, works are fired three times: two bisque and one glaze. If I'm not happy, I will refire; the maximum number has been three stoneware firings to get what I want, although I don't really want to stress the clay too much. All my glaze firings are to around 1245–1250°C (2273–2282°F).

Bright colours can also be achieved through the use of transfers as explained by Claire Partington:

Colours can be achieved with transfers – if I want to achieve a certain colour, I get a sheet of colour made and cut it up. I look at the vibrancy achieved with traditional porcelain and am able to fake it with transfers when emulating historical works.

I use transfers in other ways; I have made watercolour paintings to look like Delft, which I Photoshop and have made into transfers. I have also made textile patterns to scan and make the transfers fit exactly by measuring the work after it's fired and glazed. The transfers are quite forgiving as they are a little stretchy. I have painted cobalt directly on to unfired glaze; it was very time-consuming and a bit of a departure, but it looked nice.

Eusebio Sanchez, *Foreing Growth*, 2019, height 43cm (17in).

Claire Partington's studio: transfers arranged on glazed figure prior to firing; lustre will be added later.

Detail from finished figure created for the *Taking Tea* installation for Seattle Art Museum, 2018.

Chapter 8 – Firing, Glazing and Further Techniques 133

Patricia Volk's studio: bisque work is undercoated with primer.

Patricia Volk, *Cog*, 2019, height 40cm (16in).

Patricia Volk has never used glaze, preferring paint like a number of sculptors working with clay, particularly in the United States. This has the added benefit of using less energy:

> I work with painted clay; I enjoy the flexibility of working this way and the choice of colours available. I bisque fire my work to 1040°C (1904°F) so that it is still porous enough to absorb paint. I have amassed a colour combination library from photographs captured on my phone and through online research, noted whenever I see a combination that works. Looking at the colour in my archive, I let the work tell me what it wants, which can require a bit of trial and error – I am always prepared to reassess and have the flexibility to change my mind at any point.
>
> Starting with a black or white undercoat as a primer, I then mix a bespoke colour for the main body of the sculpture, as opposed to using a shade that is 'off the peg'. I think colour relates to size and balance, almost a mathematical combination. You use a yellow and it can only take up so much space, which you learn by instinct. Some of the colours take a while to get right because of the subtlety of different tones. Considering the form carefully, I introduce other colours, sometimes overlaid with a line, drip or a hand-painted repeated pattern that works in harmony with the curves or angles of a form. The effect as a whole must be right – if not, I will repaint until the form feels cohesive and complete. In order to make the work weather-proof and suitable for outdoor display, I will add a final layer of lacquer, which has an ultraviolet filter to protect the colours.

Contributor Profiles and Photographers' Credits

PAUL BRIGGS

An associate Professor of Art Education at the Massachusetts College of Art, Paul Briggs has studied educational theory and policy, art education, theology, sculpture and ceramics, earning an MFA from the Massachusetts College of Art, an MSED from Alfred University and a PhD in Art Education/Educational Theory and Policy from the Pennsylvania State University. With two distinct strands to his practice, he describes slab building as a primary method of expression to think through ideas and to philosophize, in contrast with pinch-forming as a meditative, intuitive process.

He was recently awarded a South Eastern Minnesota Arts Council Grant for the installation, *Cell Persona: The Impact of Incarceration on Black Lives*. Exhibitions include, 'Contemplative Clay', Swarthmore College, Pennsylvania, and 'Constructed ClayScapes', San Angelo Museum of Art, Texas. His work is held in several collections, including The Wellesley College Multifaith Centre, The University of Tennessee Ewing Gallery, and the San Angelo Museum of Art.

Paul Briggs creating a pinched form in his studio.

www.psbriggs.com
@p.briggs3.0

Images of Paul Briggs and his work are courtesy of the artist.

MARK DRAPER

Since retiring from his career as a special needs teacher with responsibilities for creative arts, Mark Draper has combined his interests in architecture and ceramics by making clay models of favourite buildings. Mark works from a studio at his home in the East Midlands, England, where he produces working architectural drawings and plaster moulds, resulting in the construction of limited editions. He does not have a commercial profile, nor does he exhibit regularly, as he works to a limited number of commissions each year. The works are very time-consuming to meticulously prepare and construct, so this book allows us a rare glimpse into his studio practice. He has exhibited at the Sir Alfred East Gallery in Kettering and at the Charles Rennie Mackintosh house, 78 Derngate, in Northampton.

Mark Draper working on a model based on Sir Thomas Tresham's Triangular Lodge.

@mark_v_draper

Images of Mark Draper and his work are courtesy of Layton Thompson.

LYNDA DRAPER

Working with clay for over thirty-five years, Lynda Draper is a graduate of, and is head of, the National Art School, in Sydney, Australia. In 2010, she completed her MFA at UNSW Art & Design, Sydney, with the assistance of a Planex Scholarship. Her imaginative, tactile sculptural works explore the relationship between the mind and material world, the related phenomenon of the metaphysical; the intersection between dreams and reality. Clay is used as a material to communicate ideas, and her style has evolved in response to life's circumstance and experience.

Lynda Draper with her work, including *Green Bottle* from 2016.

Lynda has received numerous prestigious national and international awards and her works are included in significant collections, including the National Gallery of Australia, Canberra; the International Museum of Ceramics, Faenza, Italy; the Smithsonian Institute Washington; the collection of the Dutch Royal Family and the FuLe International Ceramic Art Museum, China.

www.lyndadraper.com
@lynda_draper

Images of Lynda Draper's work are courtesy of the artist, except for the portrait image which is courtesy of Mark Draper.

MADODA FANI

Inspired by his African heritage, Madoda Fani makes coiled, burnished and smoke-fired pieces that are a contemporary evolution of the traditional ceramics indigenous to Southern Africa. He works at a large scale, building organic-shaped vessels whose smooth surfaces are punctuated by intricate, repetitive patterns that give them a scaled, insect-like appearance. He trained at Sivuyile College, the Kim Sacks School of Ceramics and has also spent time studying with established makers to learn traditional techniques such as smoke firing and burnishing.

Madoda Fani polishing smoke-fired piece, *Haystack*.

He has exhibited at Design Miami and The Salon Art + Design, and as part of the Christie's London annual design auction, completed residencies in Argentina (2009) and France (2013). He received first prize at the 2016 Ceramics Southern Africa Exhibition, as well as the Ndebele Milling & Mining Premier Award at the 2015 G&W Mineral Resources Ceramics SA Gauteng Regional Exhibition.

@fanimadoda

Images of Madoda Fani's work in Chapters 2 and 9 are courtesy of the artist; Chapter 3: Southern Guild; Chapter 4 and Chapter 7: process images courtesy of Micky Hoyle, Xigera Safari Lodge and Southern Guild; Chapter 7: finished works courtesy of Hayden Phipps and Southern Guild; Chapter 8: the artist and Southern Guild.

WANYING LIANG

Wanying Liang was born in North West China, studied for her BFA at China Central Academy of Fine Art in Beijing, then for her MFA at Alfred University, New York, graduating in 2018. Her work explores themes relating to the influences of these contrasting cultures and her making process provides a space to find calm in the creation of repetitive, expressive decorative elements. Her work is surreal, dramatic and ambitious; some works total several metres tall and are constructed from several complex components. Her work is exhibited internationally: venues include the Victoria & Albert Museum, London with Blanc de Chine, A Continuous Conversation; Collect 2020 at Somerset House, London; the Crafts Museum of CAA, Hangzhou, China, and a solo show, *I Do Not Know I Am a Guest When I Dream*, Turner Gallery, Alfred University, New York, US.

Wanying Liang with sculptural work in progress in her studio.

www.wanyingliang.com
@wanyingliang

Images of Wanying Liang's work are courtesy of the artist, except the installation image in Chapter 3: *I Do Not Know I Am Not a Guest When I Dream*, courtesy of Chengou Yu. Images courtesy of Junjun Ding: Chapter 3: final form, *Untitled* 2020; Chapter 5: 'The slab is pressed into a mould'; Chapter 6: 'Work in progress, constructed from different elements joined at leather hard, with pinched additions' and contributor portrait: 'Wanying Liang at work in her studio'.

CLAIRE PARTINGTON

Based in London, Claire Partington creates beautifully observed, intriguing and ornately detailed figures inspired by classical works. Her first degree was in sculpture from St Martin's College, London; she later returned to university to complete a second degree in Museum Studies at Leicester, UK. Her pieces are directly inspired by historic sources, which influence form, narrative and costume detail wittily combined with comment on contemporary culture and themes of status and allegiance.

Claire Partington working on figures at various stages in her studio.

A recipient of the prestigious Virginia A. Groot Foundation Grant and a Seattle Art Museum Porcelain Commission, Claire has had her work exhibited internationally at venues including the Musee Ariana, Switzerland, Kasteel van Baasbeek, Belgium and Kunstmuseum Bochum, Germany. Works are held in numerous collections, including the Victoria & Albert Museum, London. Solo shows include, *Taking Tea* at Seattle Art Museum and *The Hunting Party* at Winston Wächter, Seattle, US.

www.clairepartington.co.uk

Images of Claire Partington's work are courtesy of the artist, except Chapter 3: Installation view of *Claire Partington: Taking Tea* at Seattle Art Museum, 2019, © Seattle Art Museum. Images courtesy of Dan Weill: Chapter 1: 'detail of figure from the installation, *Taking Tea*, Seattle Art Museum, 2018; Chapter 6: 'Detail of the same piece fired, depicting the beautiful red colour of the unglazed clay'; Chapter 8: 'Detail of finished figure created for the *Taking Tea* installation for Seattle Art Museum, 2018' and 'Detail of skirt from finished figure created for the *Taking Tea* installation for Seattle Art Museum, 2018'. Four images courtesy of Matt Watts: Claire working in her studio; Chapters 2, 6 and contributor portrait.

EUSEBIO SANCHEZ

Born in Spain, Eusebio Sanchez studied History of Art at the University of Malaga before moving to the UK to study Design and Craft at Brighton University. Following graduation from a Masters in Ceramics & Glass from the Royal College of Art in London in 2017, he has been making and exhibiting his exuberant coiled sculptures alongside working as a technical demonstrator at Brighton University. Leaving the coils exposed gives the viewer an insight into his construction process, which Eusebio describes as drawing with a coil in the way a 3D printer operates. He embraces the opportunity to experiment with scale, colour and texture and in 2018 he completed a residency at the International Ceramic Research Centre in Guldagergaard, Denmark. Works have been exhibited extensively, including at the British Ceramics Biennial in Stoke-on-Trent and International Ceramics Festival, Aberystwyth, in 2019.

Eusebio Sanchez with 2019 works, *Toes in the Shore, A Convoluted Journey* and *Very Brighton.*

www.esuebiosanchez.co.uk
@eusebio_s

Images of Eusebio Sanchez and his work are courtesy of Jonathan Bassett; process shots are courtesy of Louisa Taylor.

DIRK STASCHKE

Dirk Staschke is based in Portland, Oregon; he studied for his BFA at the University of Montevallo, followed by an MFA at Alfred University in 1998. Taking inspiration from Dutch Vanitas still life paintings, his work explores the space in between sculpture and painting. Taking the 2D into 3D, the objects in the paintings are faithfully made in clay, including the frame. The back, of equal importance, reveals the supporting structure, displaying rough marks to demonstrate the qualities of raw clay.

Dirk Staschke, detail from *Structure of an Image*, 2017.

Contributor Profiles and Photographers' Credits

A recipient of the prestigious Virginia A. Groot Foundation Grant, Dirk has had his work exhibited at venues including The Fondation d'Entreprise Bernardaud, France; 5th World Ceramic Exposition Biennial, Gwango-dong, South Korea; Gallery Jones, Vancouver, Canada; and Vasa Vasorum, curated by Garth Clark at Peters Projects, Santa Fe. Works are held in collections including the Smithsonian Museum in Washington; Icheon Museum, South Korea; and Portland Art Museum.

www.artdirk.com
@dirk_staschke

Images of Dirk Staschke's work are courtesy of the artist.

PATRICIA VOLK

Born in Belfast, Northern Ireland, Patricia Volk graduated from the ceramics degree course at Bath Spa University, UK, in 1989 and has been making and exhibiting her unique ceramic sculpture ever since. A Fellow of the Royal Society of Sculptors and an RWA academician, her work is exhibited regularly in the UK and internationally and is held in collections, including those of Lord Carrington, Mary Portas, Marchmont House and Swindon Museum. In 2017 she was invited by the Trustees of the Designer Crafts Foundation to visit Israel, speaking at the symposium in Tel Hai, lecturing both in Jerusalem at the Israel Museum and at the Bet Benyamini Centre in Tel Aviv. In 2019 she was commissioned by ITV to create an on-screen ident as part of the prestigious 'ITV Creates' initiative. She has recently been included in *50 Women Sculptors*, the first book to give an overview of women sculptors from 1880 to today.

Patricia Volk, *Twilight*, 2018, height 93cm (37in).

www.patriciavolk.org
@patriciavolk

Images of Patricia Volks's works are courtesy of the artist.

JO TAYLOR

The author Jo Taylor studied for her BA in Ceramics at Bath Spa University, later returning to study for her MA, graduating with distinction in 2012. Using different types of clay, often coloured by hand, she makes sculptural work combining different construction methods inspired by an interest in architectural features.

The author, Jo Taylor.

A member of the Royal Society of Sculptors, Jo has had her work exhibited at venues such as COLLECT at the Saatchi Gallery and Somerset House, London; TATE Liverpool; Bath Abbey, Somerset; the Kasteel d'Ursel, Belgium; and online with the Tenth Korean International Ceramics Bienniale 2019.

She was commissioned to make work for a new on-screen ident for broadcast in 2019 as part of the 'ITV Creates' project. Combining making with teaching, she lectures in a range of educational settings and regularly demonstrates; she was an invited demonstrator at the International Ceramics Festival, Aberystwyth, in 2015.

www.jotaylorceramics.com
@jotaylorceramics

Images of Jo Taylor's works are courtesy of the artist, except for Chapter 1: 'detail from *Cincture* wall series'; Chapter 4: *Vari Capitelli iii*; Chapter 6: *Vari Capitelli ii* and *Pride & Joy Green i*, courtesy of John Taylor. Chapter 3: *Cincture* series and *Vari Capitelli I–iii*, courtesy of Ester Segarra & Vessel; Chapter 7: *Vari Capitelli viii*, courtesy of Agata Pec and Vessel. Chapter 4: images of coiling, Chapter 6: pulling handle sequence and Chapter 8: *Vari Capitelli vi*, courtesy of Layton Thompson. Portrait shot courtesy of Jeni Meade.

Glossary

Banding wheel: also known as a turntable or whirler, a robust metal rotating stand that allows a piece to be worked on from all angles

Bisque firing: the initial firing of a piece in a kiln, which changes it from recyclable clay into fired ceramic

Bisque ware: fired ceramic that has not been glazed

Boxwood tools: wooden sculpting tools, often sold in a set

Coil: rolled length of clay (in the style of a long sausage)

Diddler: sponge on a stick; good for fettling

Earthenware: the lower range of glaze firing

Engobe: a coloured slip applied on to bisque ware

Extruder: a metal tube with a shaped 'die' fitted to the end. Clay is forced through the tube by compression, creating a length in the shape of the 'die'

Fettling: Tidying up the surface of a raw clay piece to eliminate blemishes or smooth out joins

Firing: the process of subjecting clay to high temperatures, normally in a kiln

Flexible rib: often an old credit or loyalty card used for scraping and refining the surface of raw work

Glaze: a layer added to the surface of a bisque work to add colour and texture; applied as a liquid and fired in a kiln to earthenware or stoneware temperatures

Grog: fired ground clay, normally added to raw clay to improve the strength and shrinkage, giving a gritty texture

Kiln: insulated chamber where raw clay is subjected to extreme heat to create fired ceramic

Leather hard: raw clay that has dried a little, around halfway between soft and bone dry

Metal kidney: also known as a metal rib, used for scraping and refining the surface of a raw clay piece

Mould: structure for placing a clay slab into or onto in order to take on its shape, often made from plaster

Oxides: commercially produced mineral powders used to add colour to slips and glazes; also used with water to create a coloured wash

Porcelain: white highly plastic clay

Potters' wire: thin wire often with wooden toggles at each end, used for slicing through clay

Reclaiming: process of recycling scrap clay into a soft, usable state

Rubber kidney: a soft flexible rib excellent for smoothing raw clay surfaces

Sculpting tools: often made from metal with different shaped ends for fine modelling detail, often sold in sets

Serrated kidney: also known as a serrated rib; has a jagged edge suitable for cross-hatching a raw clay surface as part of the refining process

Slab: rolled out sheet of clay

Slab roller: large table with a heavy roller mechanism to enable the creation of large, even slabs

Slip: runny clay, normally the consistency of thick cream, used for joining (also known as slurry); can be coloured to use for decorating

Slurry: runny clay used as glue for joining

Stains: commercially produced coloured ceramic powders, purchased from a supplier

Stoneware: the higher range of glaze firing

Surform: a grater type of tool used for shaving off areas of leather hard clay, or plaster in mould making

Turntable: see Banding Wheel

Wedging: the process of kneading clay to create an even consistency

Wooden rib: a small wooden slab, often with a hole in the centre, used for shaping and scraping raw clay

Resources

RECIPES

Most makers who are featured use commercially produced glazes or do not glaze at all; the following are some of the slips and glazes featured that are made from recipes. Materials can vary between countries as they are often made from resources available in a particular region; this often happens when the material is derived from a type of clay found in a specific area. There is normally an equivalent material available locally – if you are unsure, your supplier can offer advice.

Celadon for Electric Kiln

Celadons are traditionally associated with reduction firings; this is a food-safe glaze used frequently by the author in an electric kiln with reliable results. Fire to 1260°–1280°C (2300°–2336°F) with a short soak of fifteen to twenty minutes.

Cornish stone	80
Whiting	15
China clay	3
Copper oxide	0.5
Tin	5

Euebio Sanchez's Base for Engobes Recipe

Ball Clay	35
China Clay	40
Potash Feldspar	20
Borax Frit	5

Wanying Liang Squeezing Paste Recipe

This can be used with a pastry bag:

Grolleg Kaolin	30% (china clay)
EPK	15%
XX Sagger	25% (fine particle ball clay)
Nepheline Syenite	15%
Flint	15%

add

Darvan 811	0.5% (deflocculant)
Water	25%
CMC Gum	2%
Corn Syrup	8–10%

Paul Briggs: Variegated Green Glaze

'This is my signature glaze; I aimed for one that broke extremely lightly on the edges and pooled darkly in the recesses of the surface. This is a glaze I worked on with Ben Ryterband at the Massachusetts College of Art. I've tweaked it over the years and there is also a blue version. It works well with thin to medium application to cone 04 bisque on a true cone six clay body.'

Whiting	32.5
EPK Kaolin	24.7
Alberta Slip	19.1 (UK equivalent: red art clay)
Ferro Frit 3124	14.9 (UK equivalent: High Alkaline Frit)
Flint	6
Dolomite	2.8
Bentonite	2%
Copper Carbonate	2.5% total 104.5
Water	25%
CMC Gum	2%
Corn Syrup	8–10%

SUPPLIERS (UK)

These are the main UK suppliers; there are also smaller outlets, so it is worth checking your local directory or seeking a recommendation from a nearby maker. Smaller items such as tools and stains are easy to purchase online with inexpensive postage. Heavier items, particularly clay, incur more expensive delivery costs: if collecting in person, it is worth considering buying in bulk or creating an informal system with local makers to take turns to collect supplies. Ensure the load is distributed evenly around your vehicle!

www.bathpotters.co.uk
www.clayman supplies.co.uk
www.ctmpottersupplies.co.uk
www.potclays.co.uk
www.potterycrafts.co.uk
www.scarva.com
www.valentineclays.co.uk

FIRING TEMPERATURE COMPARISON CHART: POPULAR TEMPERATURES

Celsius °C	Fahrenheit °F	Nearest Pyrometric cone	
600	1112	022	exact
700	1292	018	717°C or 1322°F
800	1472	015	804°C or 1479°F
820	1508	015	804°C or 1479°F
1000	1832	06	999°C or 1830°F
1040	1904	05	1046°C or 1914°F
1080	1976	03.5	exact
1250	2282	7	1240°C or 2264°F
1260	2300	8	1263°C or 2305°F
1280	2336	9	exact

EVENTS (UK)

A day out to see inspiring work, watch a demonstration or attend a lecture, and talk to other makers is highly recommended as both stimulating for new ideas and an enjoyable social event. Keep an eye out for regional exhibitions or festivals taking place and consider a special trip to one of these major events in the ceramics calendar:

Art in Clay, Windsor: annual outdoor summer event with over 200 exhibitors, with a programme of talks and demonstrations.
www.artinclay.co.uk

British Ceramics Biennial, Stoke-on-Trent: a bi-annual contemporary ceramics festival hosting exhibitions and events embracing the heritage of the Potteries as the home of British Ceramics.
www.britishceramicsbiennial.com

Ceramic Art London, Central Saint Martin's: annual event presented by the Craft Potters Association with over ninety exhibitors, in conjunction with a programme of talks and demonstrations.
www.ceramicartlondon.com

COLLECT, London: annual event presented by the Crafts Council, hosting over thirty international galleries, presenting over 400 contemporary craft and design makers, including a programme of talks and events.
www.craftscouncil.org.uk

International Ceramics Festival, Aberystwyth: bi-annual summer festival featuring international ceramicists demonstrating techniques, in conjunction with kiln building and firing, talks and events.
www.internationalceramicsfestival.org

The Ceramics Congress, global online festival: this is a new worldwide addition to the ceramics calendar hosted by The Ceramic School and featuring demonstrations by makers from a wide variety of countries alongside events and discussions.
www.ceramic.school

FURTHER READING

Books

Bloomfield, Linda. 2018. *The Handbook of Glaze Recipes.* Herbert Press Ltd.
Bloomfield, Linda. 2020. *New Ceramics: Special Effects Glazes.* Herbert Press Ltd.
Hooson, Duncan & Anthony Quinn. 2012. *The Workshop Guide to Ceramics.* Thames & Hudson Ltd.
Loder, Claire. 2013. *Sculpting and Handbuilding.* A&C Black.
Taylor, Louisa. 2011. *Ceramics: Tools and Techniques for the Contemporary Maker.* Jacqui Small LLP.
Taylor, Louisa. 2020. *Ceramics Masterclass.* Thames & Hudson Ltd.
Wardell, Sasha. 2017. *Slipcasting.* Herbert Press Ltd.
Wardell, Sasha. 2019. *Porcelain & Bone China.* The Crowood Press Ltd.

Journals

Ceramics Art & Perception www.mansfieldceramics.com
Ceramic Review www.ceramicreview.com
Ceramics Monthly www.ceramicartsnetwork.org
Crafts Magazine (bi-monthly) www.craftscouncil.org.uk
New Ceramics www.neue-keramic.de
Pottery Making Illustrated www.ceramicartsnetwork.org

USEFUL WEBSITES

www.australianceramics.com
www.ceramicartsnet
www.ceramics.org
www.cfileonline.org
www.craftpotters.com
www.craftscouncil.org.uk
www.digitalfire.com
www.nceca.net

Resources 143

Index

abstract 22, 77
acrylic paint 33, 46, 134
agateware 104
architecture 26–27

banding wheel 19
batt wash 116
bevel 60
biscuit 14
bisque 14, 62–63, 99, 116–118
bone dry 14
box form 60–61
burnishing 113

chemical change 117
clay
 colouring 102–103
 drying 15
 preparation 14
 reclaiming 15–16
 softening 15
 states 13–14
 types 11–13
coil/coiling 34, 37, 40–45, 68, 77–78, 89–90, 96–87
composition 27
cottle 62
cracks 87, 90
crank 12
culture and heritage 25
cylinder 58, 60

drying 81, 87, 93, 128
drying cycle 117
dust 17

earthenware 11–14, 118, 121, 123, 128
enamels 126, 128
engobes 120
extrusion/ extruding 44–45, 49, 88, 96

feet 87
fettling 42, 44
figurative 77, 89
food safe 122

glaze 14, 115, 120–123, 129–133
greenware 13
grog 11–12
guides 57–58, 66

handles 77, 84–86
health and safety 17–19
heat gun 42, 44
hole cutter 61, 101

impressed 99
inlay 113
inspiration 21–22

joining 79, 86–87

kidney 19, 39–40, 42, 44, 46
kiln
 controller 116, 118
 electric 115, 122
 elements 116
 furniture 116
 gas 122
 health and safety 18–19
 packing 116–117
 props 116
 shelf 116
 ventilation 19

landscape 21, 26
leather hard 14, 44, 60, 68, 96, 99, 101, 106
lustres 126–128

marbling 104–105
modelling 77, 92
molochite 12
museum 21, 24

nerikomi 104, 126

oxides 102, 106, 124
oxidized/oxidization 115, 121–122

paddling 44
paperclay 13, 15, 51, 77
pattern 99
perforated 101
piercing 101
pinching 26, 37–39, 51–54, 79
pit firing 127
planning 21–22
plaster 17
plasterboard 68
plaster mould 62, 82, 93
plaster bat 15
porcelain 13, 15, 22, 102
press mould 57, 62, 66–68, 72–74, 77, 92, 104–105
profile 40
pyrometric cones 118–119

raku 127
reduced/reduction 115, 121–122, 127
representational 22, 77
rib 19, 39–40, 42, 44, 46, 59
rollers 99–100

scoring 59–60, 100
sculpting/sculptural 77
shrinkage 22, 96
shrink slab 81
sieve 121
sink trap 18
sketchbook 21–22, 30–32, 77
slabbing/slabs building/ slabs 57–60, 69–72, 77–78, 89–90, 97, 99, 104
slab roller 57, 69

slip
 application 106–113
 banding 109
 combing 109
 decorating 106
 feathering 108
 joining 39–40, 44, 93
 latex resist 113
 marbling 108
 mocha 110
 monoprint 111
 painting 106
 paper resist 112
 screen printing 112
 sgrafitto 110
 sponging 107, 112
 trailing 107
 wax resist 112
smoke firing 127
snips 87
soak 118, 123
spouts 87
sprigs 77, 82–83, 89–91
stains 93, 102, 106, 124–125, 132
stamps 99–100, 113
stoneware 11–14, 22, 105, 118, 121–123, 133
studio 17
support 78, 81, 90, 92

terracotta 12
texture 99, 101
tiles 57–58
tools 19
transfers 126–127, 133
troubleshooting 87, 127

undercut 44
underglaze 106, 120, 128, 130–131

vitreous slip 120

wedging 14, 16
workspace 17